THE URBAN SKETCHING HANDBOOK

SPOTLIGHT ON NATURE
Tips & Techniques for Drawing & Painting Nature on Location

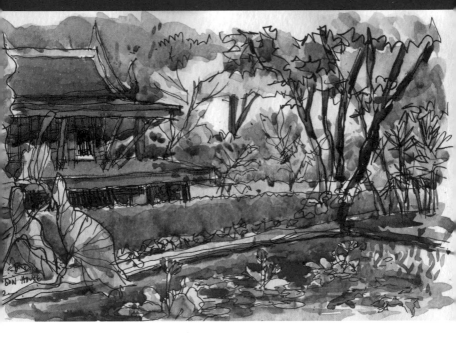

**VIRGINIA HEIN
& GAIL L. WONG**

Inspiring | Educating | Creating | Entertaining

Brimming with creative inspiration, how-to projects, and useful information to enrich your everyday life, quarto.com is a favorite destination for those pursuing their interests and passions.

First Published in 2022 by Quarry Books, an imprint of The Quarto Group, 100 Cummings Center, Suite 265-D, Beverly, MA 01915, USA.
T (978) 282-9590 F (978) 283-2742 Quarto.com

Quarry Books titles are also available at discount for retail, wholesale, promotional, and bulk purchase. For details, contact the Special Sales Manager by email at specialsales@quarto.com or by mail at The Quarto Group, Attn: Special Sales Manager, 100 Cummings Center, Suite 265-D, Beverly, MA 01915, USA.

10 9 8 7 6 5 4 3 2 1

ISBN: 978-0-7603-7455-9

Digital edition published in 2022
eISBN: 978-0-7603-7456-6

Library of Congress Control Number: 2021950821

Cover Image: Virginia Hein, *Echo Park Bridge and Palms*, Los Angeles, California, USA, 11" × 13½" | 27.9 × 34.3 cm; ink and watercolor; (back cover) Gail L. Wong, *Simple Forms*, Skagit Valley, Washington, USA, 6½" × 10" | 16.5 × 25.4 cm; direct watercolor; (page 1) Gail L. Wong, *Jim Thompson House*, Bangkok, Thailand, 5" × 8" | 12.7 × 20.3 cm; ink and watercolor; (page 3) Virginia Hein, *Descanso Garden Shed*, La Cañada, California, USA, 11" × 13½" | 27.94 x 34.29 cm; ink and watercolor
Page Layout: barefoot art graphic design

Printed in China

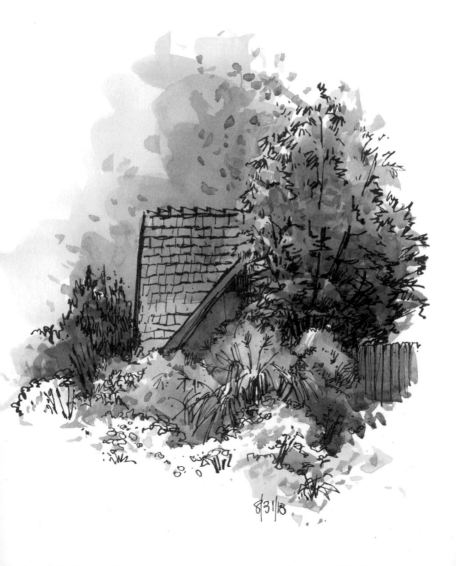

About This Series

The Urban Sketching Handbook series takes you to places around the globe through the eyes and art of urban sketchers. Each book offers a bounty of lessons, tips, and techniques for sketching on location for anyone venturing to pick up a pencil and capture their world.

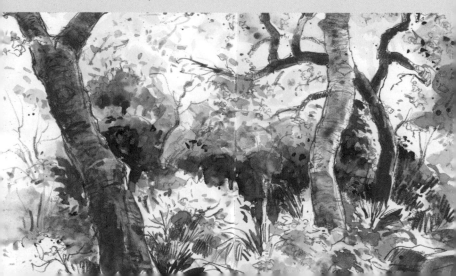

CONTENTS

☾ VIRGINIA HEIN
Japanese Garden in Summer,
La Cañada, California, USA

*13½" × 19½" | 34.3 × 49.5 cm; pencil,
watercolor, and watercolor graphite.*

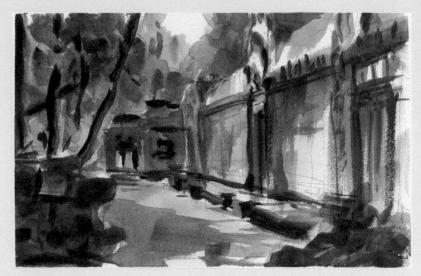

ⓝ **GAIL L. WONG**
Ta Prohm Reconstruction,
Siem Reap, Cambodia

7" × 10" | 17.8 × 25.4 cm; watercolor.

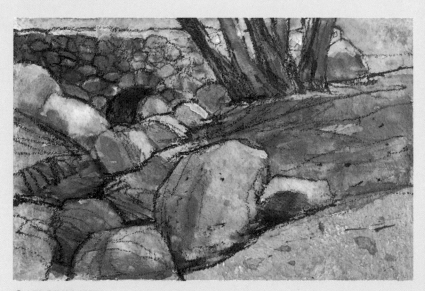

ⓝ **VIRGINIA HEIN**
Descanso Stone Bridge, La Cañada, California, USA

4" × 6" | 10.2 x 15.2 cm; pencil, watercolor, and gouache.

INTRODUCTION

Perhaps you're asking yourself, why focus on nature in an Urban Sketching Handbook? In this book we want to show you how spotlighting, or even simply suggesting, nature in a sketch is key to showing what is unique to a particular region or location.

So much of urban sketching focuses on human-made structures and humans themselves, but what we'll explore here is the role nature plays, how it shapes our natural environment and enhances our urban environments. Giving close attention to nature in every location helps us tell a deeper, richer story—bringing nature into a sketch is an important way to show the character of a place. There is a story to be told about nature wherever we are.

Nature invites us to carefully observe, so we hope you'll enjoy exploring and discovering new ways to express yourself in capturing nature around you!

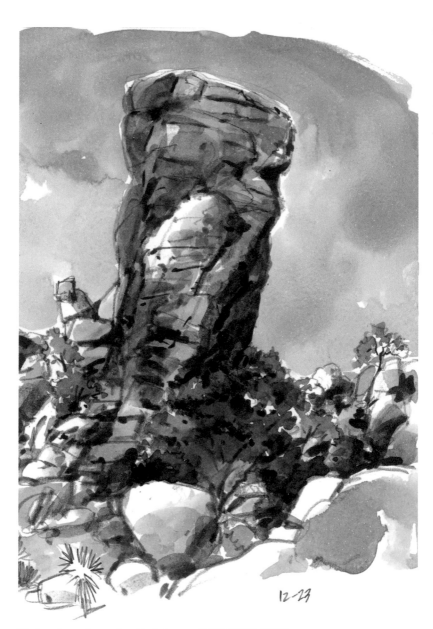

12-23

This towering rock, popular with climbers, dramatically juts above surrounding boulders against a vivid desert sky.

⊙ VIRGINIA HEIN

Hidden Valley Tower, Joshua Tree National Park, California, USA

12¼" × 9" | 31.1 x 22.9 cm; pencil and watercolor.

KEY I
HOW WE SEE NATURE

Urban sketching is all about visual storytelling. How we see nature, how important it is to our story, and where we focus our attention, shape nature's role in a sketch.

We can view nature in the broad expanse of a panorama or in the microcosm of a single leaf, flower, or acorn. We can also see nature from different and unusual points of view, from high on a hill or down in the weeds. These approaches spotlight nature in different ways.

This key explores the variety of ways you can use nature to compose your story and your sketch.

⌒ GAIL L. WONG
Shrine, Bangkok, Thailand
8" × 5" | 20.3 x 12.7 cm; ink and watercolor.

Roles Nature Plays in a Sketch

Nature can be the *main character*, the *setting*, or create a *frame* in your composition. What role it plays is up to you.

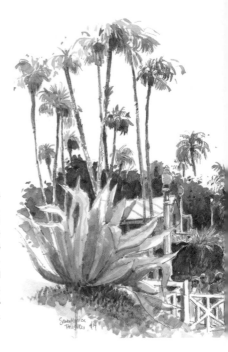

The giant century plant grabbed Virginia's attention to become the *main character* here, with the palms receding into the background of this scene. Well-known in its native Southern California, this succulent is the focal point of the sketch.

⊃ VIRGINIA HEIN
Santa Monica Palisades,
Santa Monica, California, USA
16" × 12" | 40.6 x 30.5 cm; pencil and watercolor.

Where is your story taking place? The *setting* creates the context of the story you want to tell and establishes where an event is taking place, as seen in Gail's sketch.

↻ GAIL L. WONG
Bellevue Invitational, Bellevue, Washington, USA
5" × 8" | 12.7 cm x 20.3 cm; ink and watercolor.

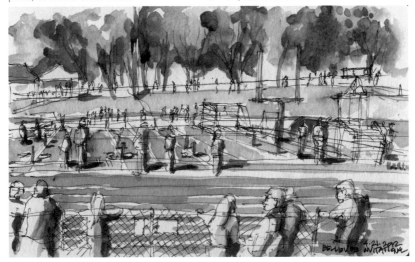

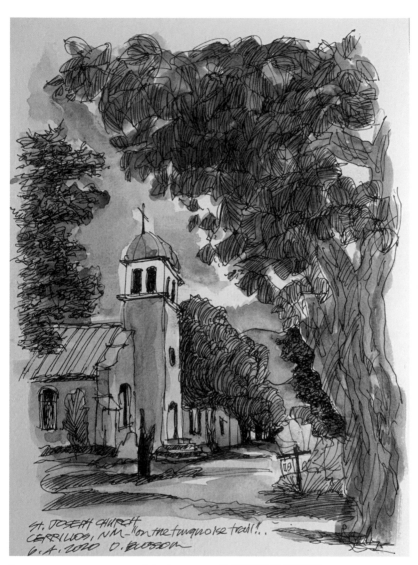

Framing a view creates a sense of depth, a hereness and thereness. Duane uses the tree very effectively as a framing device to focus our attention on the view of this historic church.

⋔ DUANE BLOSSOM
On the Turquoise Trail,
Cerrillos, New Mexico, USA

12" × 9" | 30.5 × 23 cm; ink and watercolor.

The Main Character

How do we make an element of nature the focus and main character in a sketch? These two sketches show us different approaches to creating a focus in a sketch and highlighting the main character.

⋂ VIRGINIA HEIN
The Library Tree: Moreton Bay Fig,
South Pasadena, California, USA
23" × 8¼" | 58.4 × 20.9 cm;
pencil and watercolor.

Although Virginia's sketch has many elements, the big Moreton Bay fig tree is the main character. As a town landmark, it serves as a meeting place on a prominent corner. Placing the main character in a central location on the page and using high value contrast reinforces the role and draws your eye. The background trees are less detailed and lean towards the middle like a chorus, directing your eye back into the center of the page. The shadows to the left of the tree pull your eye out of the sketch, but the converging lines of the library in the background create movement back toward the main character.

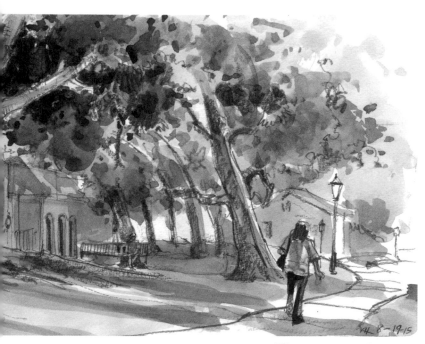

In William's highly detailed sketch, many elements could be the main character. What really stands out, though, is the bird in contrast to its green environment. Its bold color advances its presence in the sketch against the dark background, and its placement on the page, using the rule of thirds, is a prime spot in the composition.

☼ **WILLIAM CORDERO HIDALGO**

Garden Visitor: Momotus Momota, San Jose, Costa Rica

5" × 8¼" | 13 × 21 cm; ink, watercolor, and colored pencil.

The Setting

The setting gives a sense of time and place, a location, and ambience for a story. Nature can provide that in many ways with the foliage, light, and atmosphere of a specific place. It does not dominate the composition but supports the main character in your story. It can be background or foreground, but is usually subtle, with less detail than the focus of your sketch.

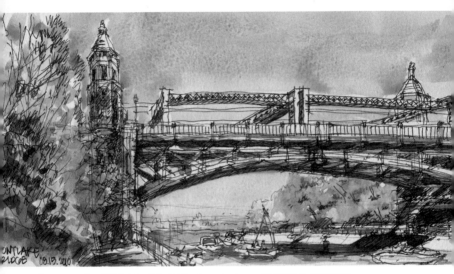

First opened in 1925, Montlake Bridge is an iconic, double-leaf bascule bridge over the Montlake Cut, in Seattle. The foreground vegetation, the waterway, and the trees edging the water set the scene for the bridge to take center stage.

⌂ GAIL L. WONG
Montlake Bridge, Seattle, Washington, USA
5" × 10" | 12.7 × 25.4 cm; ink and watercolor.

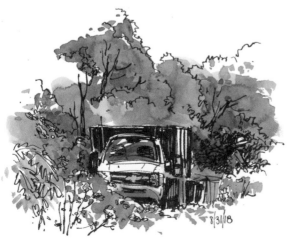

In this sketch, Virginia wanted to highlight the gardener's truck. The stark, black-and-white vehicle contrasts with the colorful foliage and becomes the focus of the sketch against the living background.

⊂ VIRGINIA HEIN
Rose Garden Vignette,
La Cañada, California, USA

8" × 10½" | 20.3 × 26.7 cm;
ink and watercolor.

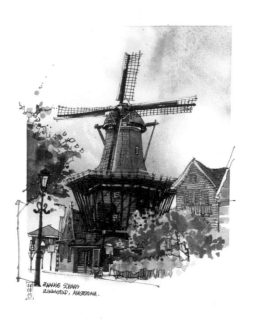

While the beautiful windmill is clearly the main character of this sketch, the suggestion of foliage in the foreground and middle ground creates the street setting.

☾ DARMAN SKETCHER
De Bleeke Dood of Zaanse Schans, Amsterdam, the Netherlands

12¼" × 9" | 31 × 23 cm; watercolor and graphite on rough watercolor paper.

In Darman's sketch, the neutral color of the background trees allows the subtle yellow of the building to advance to center stage. Notice the use of negative shapes to suggest the foreground trees on the left.

☽ DARMAN SKETCHER
O Guan Chuong Gate, Hanoi, Vietnam

11¾" × 16½" | 29.7 × 42 cm; watercolor and graphite.

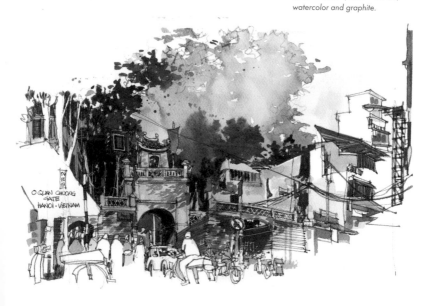

The Frame

Framing a view can create more depth and interest in
your sketch. A large tree or other natural element in
the foreground gives us a strong sense of place and
dramatically creates a window, drawing us into the scene.

A towering limestone rock,
the branch of an oak tree,
and a wooden pillar frame
a view of a family in the
distance.

◑ VIRGINIA HEIN
*Taihu Rock in the Chinese
Garden*, The Huntington,
San Marino, California, USA
*5" × 7½" | 12.7 × 21 cm;
pencil and watercolor.*

"While drawing that sculptural rock I suddenly saw a
family stop on the path, and realized I had a natural
frame of the view and sketched as fast as I could to
catch their gestures." —Virginia Hein

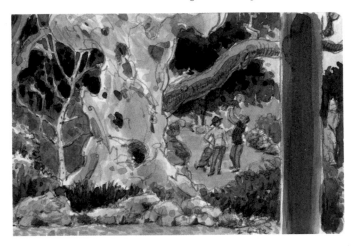

Tip

Framing is a great way to draw the viewer's
attention to a distant focal point, and it
really adds a feeling of depth and drama to
your sketch. Look for a wide-branching tree,
a leafy trellis, or other natural arch in the
foreground to frame your view.

The wide, branching tree
and cast shadow dramatically
frame the chapel entrance beyond.

⊃ DUANE BLOSSOM
The Chapel at the Carmelite Monastery,
Santa Fe, New Mexico, USA
12" × 16" | 30.5 × 40.6 cm; ink and watercolor.

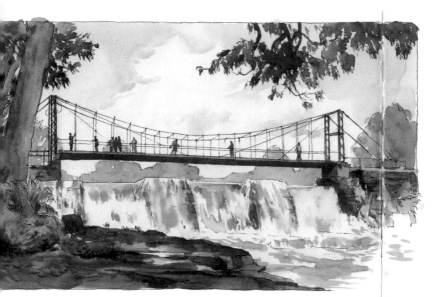

Eduardo places the viewer solidly in the foreground under the tree and on a rocky outcropping that frames the view of the bridge and waterfalls.

◯ EDUARDO BAJZEK
Bridge Over Jacare Pepira River,
São Paulo, Brazil

8¼" × 13" | 21 × 33 cm; ink and watercolor.

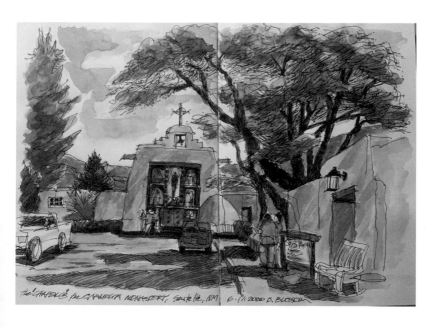

Main Character, Setting, or Frame . . . How Do You Decide?

Taking a moment to choose your focal point is probably the most important step in composing your sketch. So often when we sketch on location, we choose the first interesting subject we see and just start sketching. Walking around to see your location from different points of view can suggest a lot of ways to convey your subject. Using the concepts of The Main Character, The Setting, and The Frame, we can generate different visual stories. Here, you can see how the role you give the subject changes the composition and the narrative.

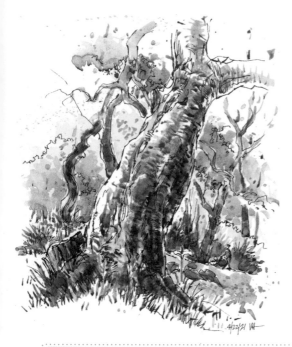

The Main Character

This coast live oak tree, with its massive, twisting trunk, presides over the grove of slim, lithe trees surrounding it, making it the main character in this view.

◲ VIRGINIA HEIN
In the Oak Forest, Coast Live Oak,
La Cañada, California, USA

11" × 13½" | 27.9 × 34.3 cm;
ink, watercolor, and water-soluble graphite.

Tip

Horizontal or vertical? The first decision as you choose a view is your composition's orientation. This all depends on what is important to your story. Here, Virginia wanted to emphasize the scale of the tree towering over the bridge and people. Quick thumbnail studies will help with decisions.

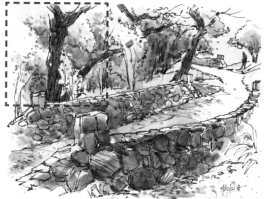

The Setting

In this sketch, the focus is the winding path across a stone bridge. The coast live oak tree is now an element of the background creating the forest setting for the bridge.

↻ **VIRGINIA HEIN**

In the Oak Forest, Stone Bridge #2,
La Cañada, California, USA

9" × 11½" | 22.8 × 29.2 cm;
ink, watercolor, and water-soluble graphite.

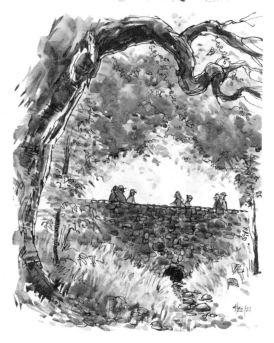

The Frame

"Standing at the base of the bridge, I noticed how the big oak tree naturally branched over my view of the bridge and people below. The main character here is the bridge, with the oak tree in the foreground creating a frame to the view." —VH

↻ **VIRGINIA HEIN**

In the Oak Forest, Stone Bridge #1,
La Cañada, California, USA

11½" × 9" | 29.2 × 22.8 cm;
ink, watercolor, and water-soluble graphite.

Workshop

Find a location, such as a public park, with a variety of different views. Choose an interesting tree or other natural element that you can approach from different angles and try sketching it in different roles: as the main character, as part of the setting, and as a frame for a view beyond.

Sky or Ground Dominance?

Another important decision you make as you compose your sketch is the location of the horizon line on your page. In a landscape drawing or painting, this is especially important since it creates a visual anchor in your scene. If your focus is on something in the foreground, you will likely want to locate the horizon line higher on your page to create a ground-dominant composition. However, if the interest is the sky, you will want to lower the location of the horizon line to create a sky-dominant composition. Placement of the horizon line either high or low determines how much ground or sky you put in your sketch.

These diagrams demonstrate different compositional scenarios.

Figure A. The horizon line is in the center. Sky and ground have equal emphasis.

Figure B. The horizon line is at the top quarter of the page. More area is given to the ground, making this a ground-dominant composition.

Figure C. The horizon line is in the lower quarter of the page, giving more area to the top portion of the page and making this a sky-dominant composition.

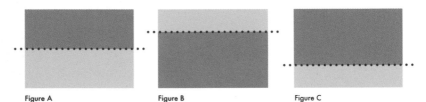

Figure A Figure B Figure C

Sky-dominant composition
☯ GAIL L. WONG
South Lake Union Skyline,
Seattle, Washington, USA
*8" × 16" | 20.3 × 40.6 cm;
pencil and watercolor.*

Here are two views of the same scene at Gas Works Park in Seattle. The one above is at ground level. Placing the horizon line lower on the page allows for the sky and skyline to dominate this sketch. The view below is from high on a hill. The horizon line is located on the upper portion of the page allowing the ground and water to dominate. Notice that you get a very different sense of the scene depending on the observer's location and how you set up your sketch.

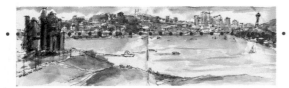

Ground-dominant composition
☯ GAIL L. WONG
Gas Works Park View,
Seattle, Washington, USA
*5" × 16" | 12.7 × 40.6 cm;
ink and watercolor.*

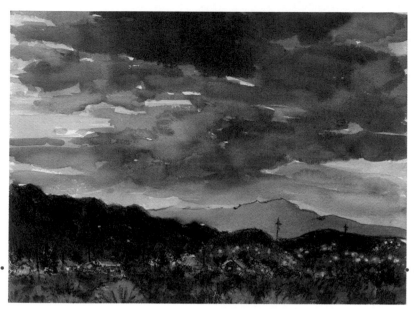

The moody sky at sunset is the focal point of this sky-dominant painting. Notice that the horizon line is in the lower part of the sketch to allow room for the sky.

⟲ VIRGINIA HEIN
Dusk in the Desert, Twentynine Palms, California, USA
9" × 12" | 22.9 × 30.5 cm; watercolor, pencil, and gouache.

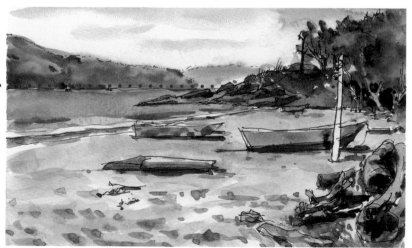

The beach dominates this scene. Gail placed the horizon line on the top half of the page to allow for more room to capture the beach, the boats, and debris in the foreground.

⟲ GAIL L. WONG
Alexander Beach, Fidalgo Island, Washington, USA
6¼" × 10¼" | 12.7 × 40.6 cm; ink and watercolor.

Uncommon Points of View

Looking at the world from an unusual viewpoint can make us see things with fresh eyes and new insights. Two points of view not commonly seen in sketching are the worm's-eye and bird's-eye views. Each can tell the story a different way. The first makes the viewer look up from below to see the underside of things. From a bird's eye view, we are high above a scene, looking down at an overall view of what is happening below us.

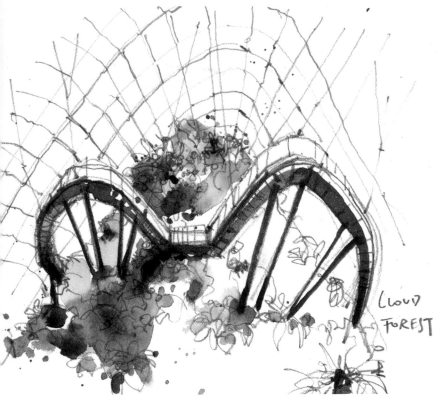

Paul is looking up at a skybridge in the Cloud Forest at Gardens by the Bay in Singapore. Inside this huge biodome is a seven story-high mountaintop forest covered in tropical plants. To convey the scale of this structure, Paul gives us a dramatic worm's-eye view of how the skybridge connects to the mountain.

◯ **PAUL WANG**
Sky Bridge at Cloud Forest,
Gardens by the Bay, Singapore
7" × 10⅝" | 18 × 27 cm; watercolor, pencil, and colored pencils.

⌒ RICHARD ALOMAR
*2021 Feaster Park, New Brunswick,
New Jersey, USA*

5" × 8½" | 12.7 × 21.6 cm; ink and watercolor.

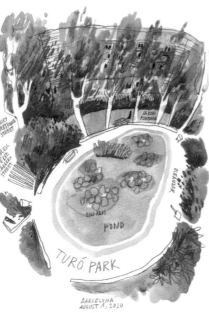

⌒ SANTI SALLÉS
Turo Park, Barcelona, Spain

11⅝" × 8¼" | 29.7 × 21cm; ink and watercolor.

Santi and Richard use bird's-eye views in their
sketches to show us the big picture of these
locations, zooming out to give us information we
would never be able to see at ground level.

⌒ RICHARD ALOMAR
*2021 Central Park,
New York City, New York, USA*

5" × 7" | 12.7 × 17.8 cm; ink and watercolor.

Workshop

Just as a filmmaker would choose an unusual camera angle for a specific reason, think
about why you might choose an unconventional point of view. Would it reveal something
you would not notice with a more conventional view—such as the arrangement and
relationships of things you could not normally see?

Try this: Sketch a view from the top. You could be looking down on a public park or
other green space from a building or high on a hill. Notice how shapes and relationships
look very different from this bird's-eye view than they do from the ground. Or, try a
worm's-eye view: draw a tall tree or a rock cliff while looking up from the ground.
How does that affect your perception of your subject?

Focus on the Details

Sketching is an opportunity to focus your attention on details in nature. Botanical studies are a wonderful way to slow down and make a careful, close-up study of nature. We can learn much about a plant and its setting in analyzing, sketching, and even taking field notes about it. Getting up close to the subject changes our point of view and allows us to see the unique characteristics and understanding of the organisms around us.

Nina's sketch of the geraniums in front of her house spotlights the blossoms against the highly detailed edges of the geranium leaves. Notice how beautifully layered the leaves are and how the varied values add to the depth of the sketch.

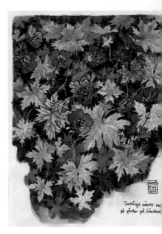

⋒ NINA JOHANSSON
Geranium Rozanne,
Communal Garden
Stockholm, Sweden
*7¾" × 9¾" | 19.7 × 24.8 cm;
ink and watercolor.*

While hiking in Yosemite National Park, Gary stopped to study and sketch the details of river rocks and the movement of rippling water, shaded by a sugar pine.

☾ GARY GERATHS
Tuolumne Meadows—First Snows,
Mono Pass, California, USA
*12" × 6" | 30.5 × 15.2 cm; pencil, ink,
fountain pen, and white-out pen.*

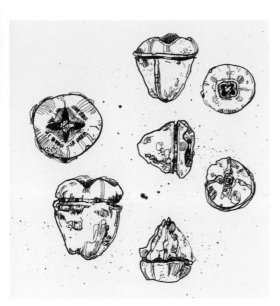

Genine made close-up studies of eucalyptus pods she found on her walk. It is interesting to see her study these natural beauties in top, front, side, and bottom views as an architect might study a building. The highly detailed sketch gives a sense of the surface characteristics of this pod.

↻ GENINE CARVALHEIRA
Eucalyptus Pods,
Bogota, Columbia

*8" × 8" | 20.3 × 20.3 cm;
dip pen and ink.*

During the summer, Mariia started trying to raise silkworms "to understand first-hand how Japanese farmers did it in villages a couple of decades ago." Here we see her sketches and notes showing closeup studies of a mulberry leaf being eaten by one of her silkworms.

⮌ MARIIA ERMILOVA-TERADA
Silkworm Feeding on the Mulberry Leaves,
Matsudo, Japan

7" × 5" | 17 × 12 cm; watercolor; colored pencils; fude pen, 55° angle tip.

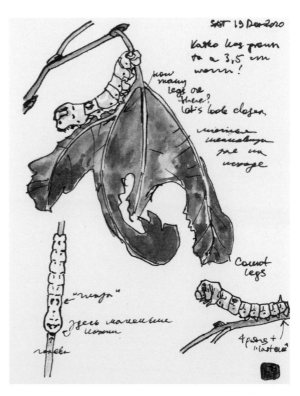

Zooming In and Zooming Out

Zooming in to get a close-up view of a subject can reveal a world
of surprising details, things we otherwise would never notice.
When we step back to zoom out, we can see the context of our
subject—how it fits into the broader environment.

William sketches both an up-close detail of the plant
frond as well as the garden setting in which it resides.
He did this as part of a series of botanical and garden
sketches during "lockdown" in the first weeks of the
2020 Pandemic.

**◑ WILLIAM CORDERO
HIDALGO**
Nature Study, Costa Rica
5" × 8½" | 13 × 21 cm; ink, watercolor,
and colored pencil.

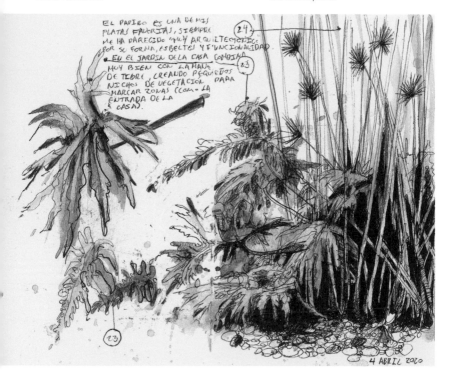

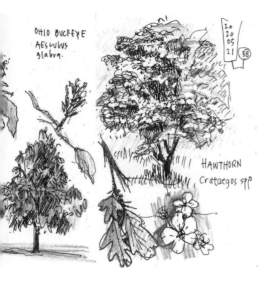

OHIO BUCKEYE
AESCULUS
glabra.

HAWTHORN
Crataegus spp

During the beginning of the pandemic, Richard would go to Central Park to "sketch trees, flowers, and park spaces as a way to connect to a stable place and feel continuity with pre-pandemic times." Here we see him zooming in to draw the details of the blooms and leaves and then zooming out to see the natural form, shape, and branching of the trees.

☾ RICHARD ALOMAR
2021 Central Park,
New York City, New York, USA

5½" × 7" | 14 × 17.8 cm;
ink, and colored pencil.

Workshop

Take a walk in your neighborhood, your local park, or conservatory. Find a flowering plant or tree that strikes your interest.

Zoom in: Focus on the blooms, bark, and leaves. Look at the shape, color, and how it attaches to the branches. How does it organize itself along a branch, how is it structured? How many petals or leaves does it have? If it is spring, you can do several sketches over time to show how the flowers evolve from buds to full flowers and die back to leave room for the leaf development. Describe in words and measurements what you understand of the organism you are drawing.

Zoom out: Draw the plant in the context of its setting. Look at the shape and proportions of this plant or tree. Locate the pattern of flowers on the plant. How does it grow: individually or naturally cluster in groups? What is the natural ecosystem surrounding the plant? Is it a plant that thrives under the shade of another plant, or does it thrive directly in the sun?

◯ CH'NG KIAH KIEAN
Wild Flowers Series III partial detail, Penang, Malaysia

26" × 6½" | 66 × 16.5 cm;
graphite and watercolor.

Nina's expressive line work reveals the gnarled nature of the trunk and branching of this tree.

⌂ NINA KHASHCHINA
Gnarly Tree, Saratoga, California, USA
10½" × 8" | 26.7 × 20.3 cm; ink and flex nib pen.

KEY II
HOW WE DRAW NATURE

How can we possibly represent the overwhelming variety of forms, surfaces, and textures that we find in nature, and where do we even start? First, we will take a step back to break down the big picture, beginning with basic shape and proportion to the underlying structure. We will then move closer to look at pattern and detail. What can light reveal about surface texture, and how do we draw it? How do we see and represent depth?

We will look at a variety of approaches and techniques to help you sketch what you see. While drawing nature, consider where you want to explore your subject with lots of interesting patterns and texture or where you might choose to be selective for maximum effect. We will look into these and other topics that help us draw and paint what we see in nature.

◑ **VIRGINIA HEIN**
Tree in Contour Line, La Cañada, California, USA
11" × 9¼" | 27.9 × 24.1 cm; pencil.

⊃ SUE HESTON
City of Rocks,
Grant County, New Mexico, USA
5½" × 7" | 14 × 17.8 cm;
fountain pen and ink with ink washes.

Finding Shape

Shape is the first thing our eyes see and how we recognize objects and people. Observing how the shapes of objects divide space helps us to see composition. The shapes that define objects, called "positive shapes," and the void spaces—the "negative shapes"—are intertwined. Each are equally important in creating a strong composition.

Are these shapes creating an interesting pattern on the page? Are they varied in size? Do they create compositional balance? These are questions you can ask yourself as you begin your sketch.

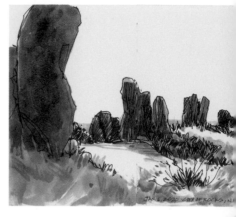

Positive shapes depict the objects we see.

Negative shapes depict the void spaces around the objects.

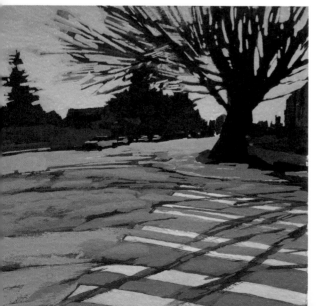

Sue painted this with gouache, an opaque paint that allows for painting light over dark. This was useful as she "painted the tree first, very loosely, and then used the light sky color to paint the negative shapes between the branches."

☾ SUE HESTON
City Tree,
Seattle, Washington, USA
6" × 6" | 15.2 × 15.2 cm;
gouache.

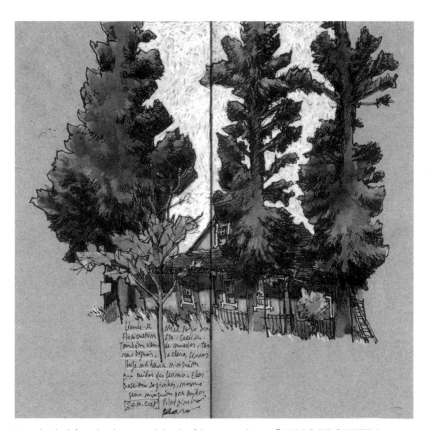

Raro clearly defines the shapes and details of the trees within the outlined shapes. It is interesting to see how the negative shapes of the sky are just as important as the positive shapes of the trees, with the space between the trees reinforced in white. As he says, "The landscapes are revealed and hidden. Some go unnoticed even when they are within reach."

ᴖ RARO DE OLIVEIRA
Floristry in the Middle of Trees,
Curitiba City, Brazil

11⅜" × 8¼" | 29 × 21 cm; ink and watercolor on kraft sketchbook.

Tip

Use shape studies to look for good compositions. Look for interesting negative as well as positive shapes. Think about balancing big shapes with smaller ones.

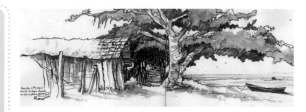

ᴖ RARO DE OLIVEIRA
Tree by the Sea, Vila da Glória,
São Francisco do Sul City, Brazil

5¾" × 16¼" | 14.7 × 41.7 cm; ink and watercolor on kraft sketchbook.

Finding Proportion

Proportions create the uniqueness of every natural element. This is especially true when it comes to drawing trees. You can see two similar trees side by side, and what distinguishes one tree from another are the relative proportions, as seen in the palm trees on the opposite page.

Sighting In **Figures A and B**, the unit of measurement is the trunk. Use a pencil as a sighting device to establish the height of the trunk between the tip of the pencil and the thumb. Carry that unit of measure up vertically to see how many units high the crown is compared to the trunk.

In **Figure C** (bottom right), notice how you can find the proportions of a tall coniferous tree: use the overall width of the tree as a measuring unit and compare that to the overall height.

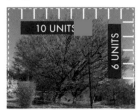

Figure A

Figure B

> ### Tip
> Keep your measuring tool consistently at an arm's-length from your eye when measuring. You can use these methods of measuring and comparing relative proportions in drawing all kinds of natural elements.
>
> Gail uses her pencil as a measuring tool to sight and compare width to height of the tree in **Figures D and E**.

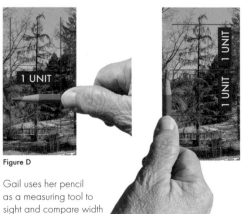

Figure D

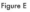

Figure E

Gail uses her pencil as a measuring tool to sight and compare width to height of the tree in Figure D and E.

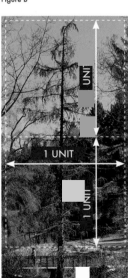

Figure C

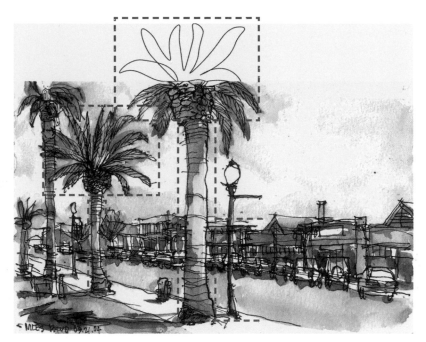

We can compare the different proportions between the two palm trees. The crown of the shorter tree is half the total height of the tree, while the crown of the taller tree is one-third the overall height.

⋂ GAIL L. WONG
Niles Boulevard,
Niles, California, USA
5" × 8" | 12.7 × 20.3 cm;
ink and watercolor.

The crown of the palm tree in the sketch to the right has about a 1:1 proportion. The trunk is equal to the crown in height but half the width.

⊃ VIRGINIA HEIN
Morongo Canyon Palm,
Morongo Valley,
California, USA

8¾" × 8½" | 22.2 × 21.6 cm;
pencil, watercolor, and gouache
on tan paper.

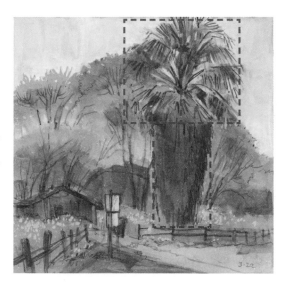

Finding Structure

Seeing structure helps us to understand the branching and scaffolding (the primary limbs) of a tree. Is there a main leader trunk or is the tree multi-stemmed? What is the direction of the branching? All these structural elements reveal the tree's growth pattern, shape, and the unique characteristics of the tree you are drawing.

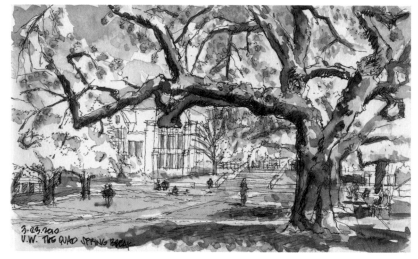

The iconic cherry trees at the University of Washington bring throngs of people to the Quad in springtime. But the unusual twisting, branching pattern of this venerable tree's structure is even more impressive than the blossoms.

◯ GAIL L. WONG
Spring Break at the Quad, UW,
Seattle, Washington, USA
5" × 8" | 12.7 × 20.3 cm; ink and watercolor.

The diagrams below clearly show the structure and branching of these trees, making each different from the other. Observing this helps us to draw the unique characteristics of the tree.

�)️ GAIL L. WONG
Tree Structure Diagrams, Seattle, Washington, USA
ink and pencil

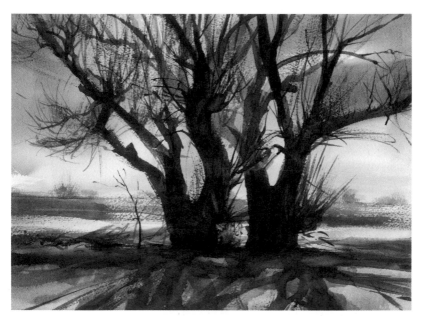

Laurie dramatically depicts the structure of this tree with its strong shapes silhouetted against the sky. She discovered that dry brushing a clump of branches caught the look of the bare shoots better than laboriously painting a lot of individual lines.

⋔ LAURIE WIGHAM

Delta Tree, Sacramento/San Joaquin River Delta, California, USA

15" × 11" | 38.1 × 27.9 cm; watercolor.

Workshop

Tree structure is best viewed in fall or winter, when the leaves of a tree have dropped. First, lightly block out the proportions of the tree, comparing the crown to the trunk. Then, observe the way the tree branches; is it upward and vertical or does it spread outward? Does it bend down at the ends of the branches? Focus on the simple structure of the tree.

Drawing Foliage

Once you establish structure in your tree sketch, look at the clumping of groups of leaves or needles. How do they attach themselves to the branches? What is their growth pattern and direction? Each type of tree is unique in this way. The "sky holes"—patterns of openings that allow us to see sky through the leaves—also impact how we read the tree.

In Paul's tree sketches to the left, notice how light and shadow reveal the way foliage clumps into groups. Paul uses fine line hatching to develop the values in the foliage. He adds more dark lines on the shaded side of the clumps to build depth. The dark value of the trunk beneath the foliage adds to the light, form, and volume in this drawing.

☾ PAUL HEASTON
Fairmount Cemetery Trees,
Denver, Colorado, USA

5" × 8" | 12.7 × 20.3 cm; ink pen.

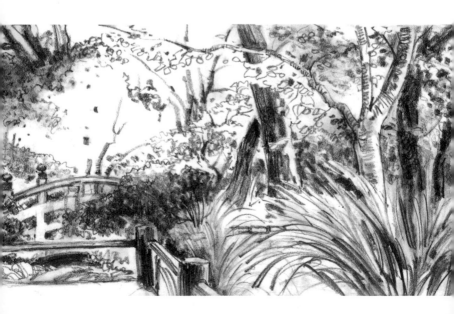

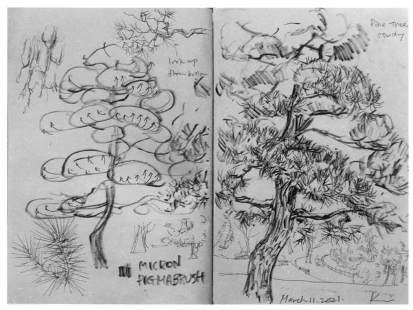

It is evident in her sketch that Kumi carefully studied the direction of growth of pine needles and observed how they grow in distinct groupings.

∩ KUMI MATSUKAWA
Pine Tree Study, Sagamihara Park, Sagamihara
Kanagawa Prefecture, Japan

11⁷⁄₁₀" × 16½" | 29.6 × 59.2 cm; ink, brush pen, fountain pen, ball point pen, and colored pencil.

Tip

Remember to observe and leave pockets or holes between masses of leaves. "Sky holes" give you the idea of groupings of leaves and open areas of light and air.

Virginia looked for patterns of light and shadow to move the eye across the page in drawing this black-and-white panoramic scene. With more light and detail in the foreground, massing the dark foliage shapes simplifies the background.

☾ VIRGINIA HEIN
Japanese Garden in Light and Shade, La Cañada, California, USA

23¾" × 8" | 60.3 × 20.3 cm; pencil.

The Versatile Line

Drawing with line can be a very expressive way to create detail and texture. There are some things that line does especially well: clearly define edges, create an elegantly expressive contour, show direction, or build patterns and texture. Depending on the weight and energy of your line, you will not only describe the details in your subject but can also express a sense of its character and feeling.

Every drawing tool has its own character and creates a different kind of line. Experiment with a variety of tools to see how they change the character of your drawing.

Sue picked up these leaves on one of her daily walks. The spaces between the stems and leaves intrigued her. Notice the elegant simplicity of the drawing; the continuous line that captures the leaf shapes, as well as the fine detail in the stems.

☾ SUE HESTON
Leaves,
Seattle, Washington, USA
8" × 10" | 20.3 × 25.4 cm;
fountain pen and ink.

Workshop

Focus on the line. Draw a plant, a flower, a twig, a pinecone up close. Try to find contour lines that express the quality of its surface and the essence of the shapes. Draw a scene with trees using only lines to convey the shapes, massing, and structure or branching of the trees you see.

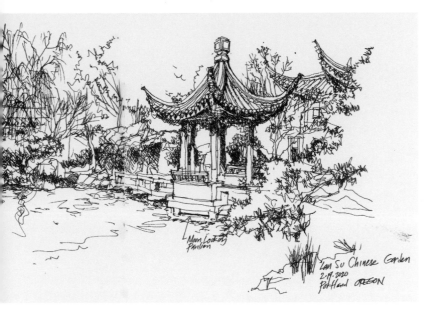

Frank's energetic lines describe a variety of surfaces, textures, and the character of different plants. He creates a range of values through a buildup of layers of lines, using a fine line fountain pen.

◑ FRANK CHING
Lan Su Chinese Garden, Portland, Oregon, USA
5" × 8" | 12.7 × 20.3 cm; ink.

In Frank's sketch above and Don's sketch below, the artists use lines to build texture and density.

Notice how the weight and direction of Don's expressive lines convey depth and suggest patterns of growth in the foliage. The values are immediately bold and dark in one stroke with the use of a brush pen. He creates lighter values using watercolor or diluted ink.

◑ DON LOW
Gyeongju National Museum, Gyeongju, South Korea
15¾" × 7¾" | 40 × 20 cm; brush pen, ink, and watercolor.

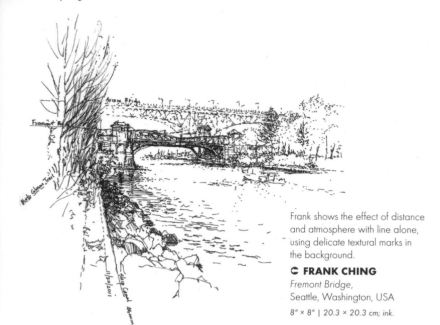

Frank shows the effect of distance and atmosphere with line alone, using delicate textural marks in the background.

☾ FRANK CHING
Fremont Bridge,
Seattle, Washington, USA
8" × 8" | 20.3 × 20.3 cm; ink.

Creating an Illusion of Depth

Showing depth in a drawing is all about how we see. In nature, we may not have perspective cues but we can see depth in different ways. Relative size and the effects of atmospheric perspective give you a sense of depth. You will notice that what is closest to you has the most detail and contrast, and the further away things are, the less detail we see. Atmosphere also softens forms and colors in the distance.

Fred made this lyrical monochrome drawing while sitting at a saltwater estuary on a spot that low tide made available. Notice how the detail in the waving patterns of seagrasses in the foreground draw your eye and how he conveys the effects of atmosphere by making the background recede into the distance with soft silhouette shapes.

⊃ FRED LYNCH
Overlooking Annisquam, Gloucester,
Gloucester, Massachusetts, USA
10" × 8" | 25.4. × 20.3 cm;
brown ink and pencil, ink wash.

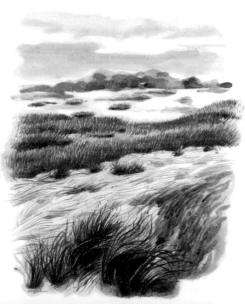

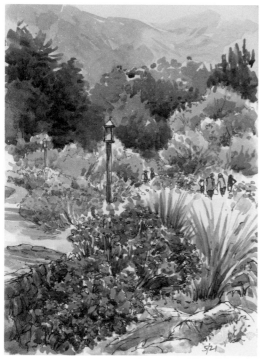

☾ VIRGINIA HEIN
Rose Garden in May, La
Cañada, California, USA
*10" × 13¾" | 25.4 × 34.9 cm;
ink and watercolor.*

Seeing Depth in Three Planes

A very effective way to understand depth in a scene is to divide it into foreground, middle ground, and background. In this scene, notice that you see more detail and contrast in the foreground. Light in the garden helped to separate the planes, with the middle ground in bright light and the background more in shadow.

Background: Least detail and contrast, muted colors; foliage may appear as silhouette shapes.

Middle ground: Less detail and less contrast in foliage; look for simple shadow patterns.

Foreground: What is closest to you will appear largest in size. We see the most detail and the greatest contrast of light and dark.

Workshop

Look for a scene where you have a good distant view, with natural elements close up and far away. Try separating the planes as in the sketch above. Some views are easier to separate than others, but it is a very helpful way to see and understand depth in your scene.

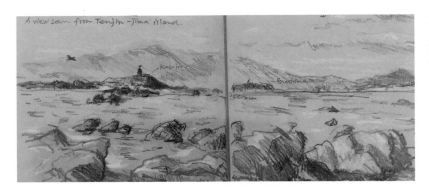

Kumi models sharp planes on rocks in the foreground with quick, directional strokes and creates soft, sloping planes in the background to suggest the distant mountain range.

⌒ KUMI MATSUKAWA

A View Seen from Tenjin-Jima Island (partial), Kanagawa, Japan

11¾" × 16½" | 29.6 × 59.2 cm; pencils on toned paper.

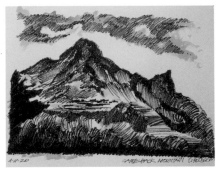

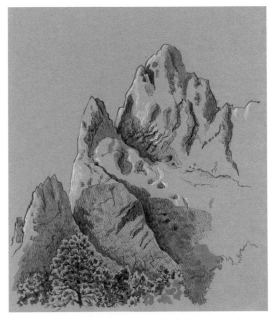

Duane carves sharp planes in the mountain with strong directional lines and bold shadow patterns.

⌒ DUANE BLOSSOM

Camelback Mountain, Phoenix, Arizona, USA

9" × 12" | 22.8 × 30.4 cm; ink, fine point and sign pen.

Paul conveys the feeling of rock surfaces bathed in light while building texture in the shadow areas.

☾ PAUL HEASTON

Garden of the Gods, Colorado Springs, Colorado, USA

10" × 8" | 25.4 × 20.3 cm; fude fountain pen, diluted gray ink wash, white gel pen on toned paper.

Creating Volume

Boulders and rocks are a great subject for observing the play of light and shadow on surfaces, revealing form and volume. Depending on the type of rock, weather, time of day, and distance, we may see sharply defined planes or soft modeling of forms. Light also reveals how rocks and mountains have surface planes that formed in different directions. Creating a convincing sense of three-dimensionality in rocks and mountains begins with observing those patterns of light.

This rock study shows the effect of bright morning light. Virginia created a quick thumbnail to see patterns of light and shadow indicating the direction of the rock surface planes.

 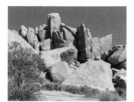

"These boulders are lined with many cracks, and in my line drawing I wanted to show how, like contour lines, they wrap around the surfaces." —VH

➲ **VIRGINIA HEIN**
Rock Face Study Step 1,
Joshua Tree National Park,
California, USA

11¼" × 8¾" | 28.6 × 22.2cm; ink.

"Here, I used watercolor wash to show that some planes have sharp edges and some are softly rounded, then added just a bit of texture. Notice here that cast shadows follow the form of the surface they fall upon." —VH

➲ **VIRGINIA HEIN**
Rock Face Study Step 2,
Joshua Tree National Park,
California, USA

11¼" × 8¾" | 28.6 × 22.2 cm;
ink and watercolor.

Drawing and Painting Flowers

In a field of greens, a bright spot of color draws your eye. With intricate shape and delicacy, or the boldness of large blooms, flowers attract us. They create seasonal spotlights in nature. Here are some different approaches to drawing and painting them.

Nina's calligraphic ink lines dance across the page as they reveal the different shapes of the magnolia blossoms. Watercolor delicately adds some depth and color to the shapes and contours of the petals.

⊃ NINA KHASHCHINA
Magnolia in Bloom 2021, Filoli Historic Garden, Woodside, California, USA

11" × 8" | 27.9 × 20.3 cm; ink and watercolor.

In April of 2020, Kay started a series of flower sketches, drawing a plant a day. She drew random flowers with the detailed accuracy of a botanical sketch. Notice how just the slightest bit of color becomes the focal point of each study.

⊍ KAY FRENCH
April Flowers, various gardens, Portland, Oregon, USA

10½" × 16" | 26.7 × 40.6 cm; water-soluble ink and colored pencil.

"It helped get me out of the house and gave me a purpose to those early days of pandemic lockdown."
—Kay French

In this fresh bouquet, a bit of line gives structure to flower and leaf shapes that Shari paints freely yet accurately. She uses the technique of negative painting (painting a darker color in the negative space around an object) to make the muted green leaves recede and pull the flowers forward.

⊃ SHARI BLAUKOPF
Flower Share 2, Beaconsfield, Quebec, Canada

12" × 9" | 30.5 × 22.9 cm; pencil and watercolor.

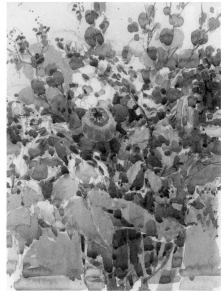

Figure A

Figure B

Figure C

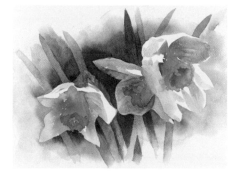

A Negative Painting Process

Figure A. Paint the negative space, or background, to define the shape of the flowers.

Figure B. Paint the interior of the petals to define the center of the flower.

Figure C. Paint the negative spaces in the background to define the background leaves.

Here we see Kris's use of negative painting in these daffodils. She lightly draws the shape of the flowers and leaves, then works from light to dark to paint the negative shapes, allowing the positive shapes of flowers and leaves to emerge. Notice how reserving the white of the paper on the petals creates brilliant highlights.

⋂ KRIS WILTSE
Daffodils, Clinton, Washington, USA

7" × 10¼" | 17.8 × 25.9 cm; watercolor.

Drawing and Painting Foliage

It's interesting that the human eye recognizes more shades of green than any other color. When you consider all the different greens in the natural world, that is understandable. To create natural-looking foliage, it is important to vary the range of greens. In the examples here, foliage takes center stage with some different approaches to creating depth and detail.

Eduardo uses direct watercolor (painting with little or no under drawing) to create a rich variety of foliage shapes with depth and well-chosen areas of detail. Notice how soft, muted greens merely suggest the background foliage. He used negative painting to carve out light, saturated greens, creating depth and detail.

⊃ EDUARDO BAJZEK
At a Garden's Inn, Paraty, Brazil
7⅞" × 7⅞" | 20 × 20 cm; watercolor on rough watercolor block.

◡ GAIL L. WONG
*Approach to Painting Trees,
pencil and watercolor*

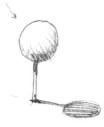

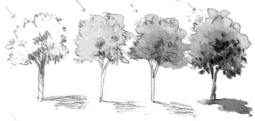

Tip

When drawing and painting trees, think about simplifying the forms to their most basic volumes. A single-stemmed tree would be similar to a sphere on a stick. Notice the sun hitting the light side of that sphere and the shade gently wrapping around the rounded surface with a graduated tone from light to dark. The crown of a tree would receive light in a similar way, with a cast shadow on the ground behind it. When painting the tree, work in layers from light to dark. Apply your lightest color first, then layer in a medium-value color. The final layer will be the darkest value for areas in shadow. Notice how foliage in sunlight is often a warmer color and foliage in deep shadow is often a cooler color.

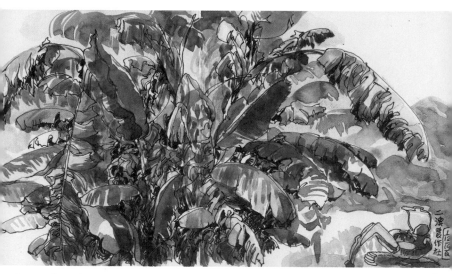

Ben uses line to bring structure and detail to the massive plant above. Notice how leaves in soft silhouette shape recede to the background.

☊ BEN LUK
Banana Tree, Yi O, Hong Kong, China

8¼" × 16½" | 20.9 × 41.9 cm;
ink and watercolor.

In Eduardo's painting, the negative white space is as important as painted shapes in creating an elegant composition.

⊃ EDUARDO BAJZEK
Banana Plant, Paraty, Brazil

7⅞" × 7⅞" | 20 × 20 cm; watercolor on rough
watercolor block.

Banana plants from opposite sides of the globe are the subject of these two sketches, each of which demonstrates a very different approach.

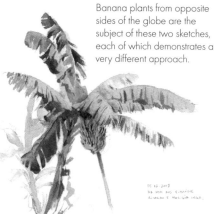

Workshop

Try different approaches to the same subject. For instance, draw with line first, then add color; or try using line as an accent to color. Let the line or color shapes predominate in your sketch. Consider these ideas:

—Use lines to emphasize a detail in the foreground.

—Use muted watercolor washes to make background areas recede.

—Try negative watercolor painting with high contrast to create depth.

—Let the white of the paper create bright highlights in your subject or create interesting negative shapes around your subject.

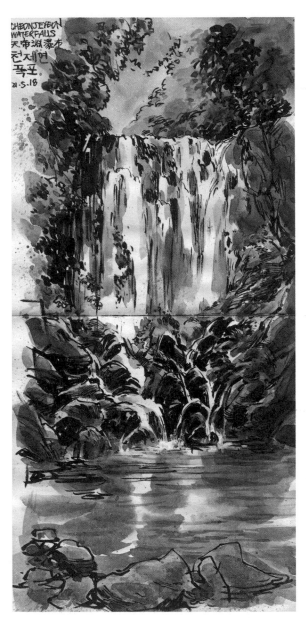

Don's sketch conveys a strong sense of the character of this place; you can almost hear the water tumbling down onto craggy rocks below.

⋂ DON LOW
Waterfall at Cheonjeyeon, Jeju Do, Korea
15¾" × 7⅞" | 40 × 20 cm; ink and watercolor.

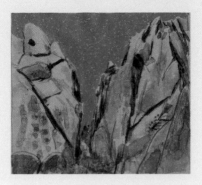

KEY III
FINDING THE
CHARACTER OF
A PLACE

What is it that makes a place memorable? Every place has its own character—the topography and terrain that define it, the features that shape it into what it is. Mountains and oceans, seas, rivers, rocks, and trees change slowly over time. But just as important and equally memorable are those elements of nature that change with the seasons, the time of day, or the weather—such as a sudden thunderstorm that appears seemingly out of nowhere. Whether nature is the focus of your sketch or the atmosphere that gives it the flavor of a particular event in time and location, capturing the character of place is key to telling a memorable story in your sketch.

◌ VIRGINIA HEIN
Split Rock, Joshua Tree National Park, California, USA
9¼" × 10" | 23.5 × 25.4 cm;
pencil, watercolor, and gouache on tan paper.

Regional Character

What makes one place different from another? Geology, climate, and local weather are important elements in shaping the character of a location.

Visitors come from all over the world to see the mile-deep gorge of the Grand Canyon and its towering sandstone layers, carved by millions of years of erosion by river and wind and unique tectonic activity. By contrast, in regions such as the Pacific Northwest, a combination of geological events formed rugged mountains with varying climates—from dense forests to alpine tundra above the tree line, depending on the altitude. Compare that to the soft, rolling foothills of northern California, with a climate of dry summers and moist winters that produce the iconic chaparral view in Barbara's sketch on the opposite page. Each view reveals distinct characteristics of the region.

"Painting at the Grand Canyon in between winter snowstorms, I was challenged by the drastically changing cloud shadows rolling over those beautiful, colorful red towers." —Gary Geraths

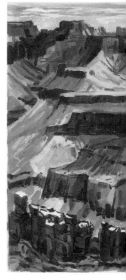

⌒ **GARY GERATHS**
Powell Point,
Grand Canyon, Arizona, USA
8" x 5" | 20.3 x 12.7 cm; gouache

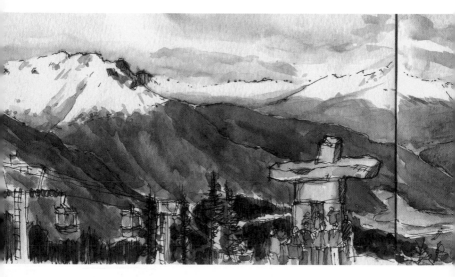

Barbara captures these oak-covered foothills with what she describes as "the colors of summer in the golden grasses and the vivid cloudless blue skies of California."

⊃ **BARBARA TAPP**
California Gold,
Winters, California, USA

7" × 7" | 17.8 × 17.8 cm; watercolor on 140# cold press watercolor paper.

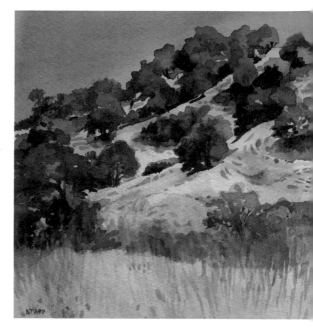

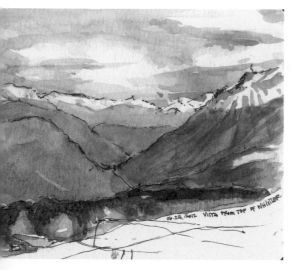

"In this panorama, we feel we are at the top of the world. I was trying to capture what that felt like, the broad vista, the distance and atmospheric perspective seen through the layers and various color changes as the mountain range receded."
—GLW

○ GAIL L. WONG
View from the Top of Whistler, Whistler, British Columbia, Canada

5" × 16" | 12.7 × 40.64 cm; ink and watercolor.

Capturing the Local Terrain

The natural features of the land help to establish the character of a region. Forces of wind and weather shape the land over time and create an infinite variety of surface textures. As you look at the surface of a cliff face, a rock, or a velvety green hillside, consider what tools and materials could give you the visual feel of that surface. Do you see strong, sharp planes; jagged edges; or softly weathered surfaces? You can use a variety of approaches to convey hard and soft edges, as in these sketches.

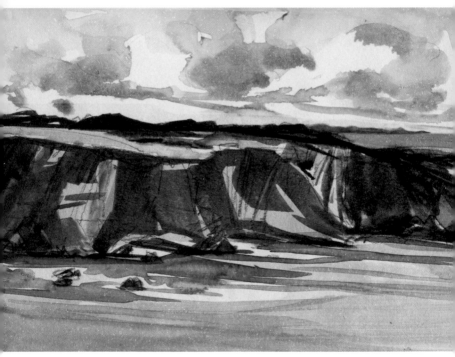

You can feel how quickly Laura captured these dramatic cliffs while on a hike with friends. Bold watercolor strokes and a few gestural lines create sharp edges that describe the massive, rocky cliff faces.

↑ LAURA MURPHY FRANKSTONE
Caerfai Bay and Cliffs, St. Davids, Pembrokeshire, Wales
5½" × 8½" | 14 × 21.6 cm;
extra soft oil pencil and watercolor.

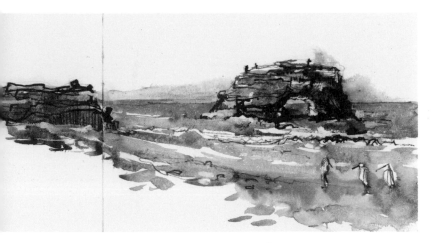

With a combination of expressive ink line and quick watercolor washes, Suhita conveys the craggy surfaces of these rocks as well as the movement of ocean waves that have carved them over eons. Notice how hatched lines indicate the direction of the rock plane on the left.

◠ SUHITA SHIRODKAR
Natural Bridges Beach, Santa Cruz, California, USA
14" × 5" | 35.6 × 12.7 cm; watercolor, pen, and ink.

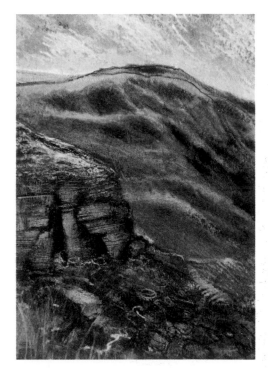

David uses soft edges to create the feel of soft moss-covered terrain and weathered rock with layers of mixed media: gouache, pastel, and colored pencil.

◡ DAVID LOWTHER
The Hill above Chinley, Chinley Churn, Derbyshire, UK
11¾" × 8¼" | 29.7 × 21 cm; gouache, pastel, and colored pencil on hot press watercolor paper.

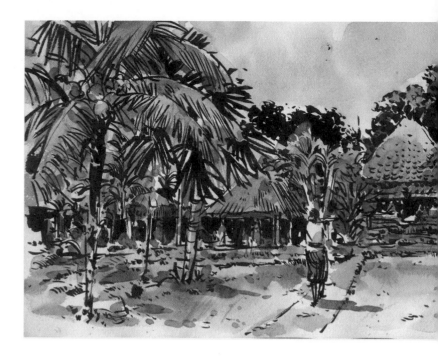

A Path in the Forest

Dense vegetation characterizes nearly every forest in the world. Just as you might look for a path to explore a forest, it is a great strategy for sketching one. When looking at a densely wooded area, find an opening, a visual entryway for the viewer. Create pathways in your sketch with patterns of light and shadow, or by contrasting masses of trees with open space.

Light generally travels from the top down into a forest, where the thick foliage filters the dappled light, illuminating interior spaces. Gary's sketch focuses on the "patterns of light and shadow shapes flowing over the natural forms."

⋂ GARY GERATHS
Late Summer Yosemite Falls Trail,
Yosemite Valley, California, USA

5" × 16" | 12.7 × 40.60 cm; gouache.

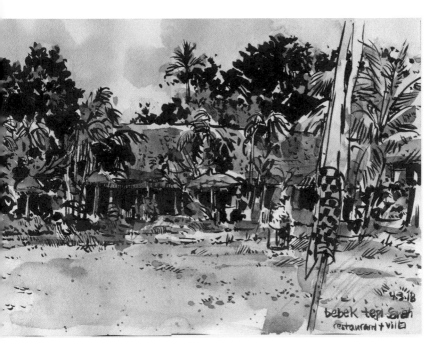

You can almost feel the humidity in this tropical setting with lush green palms. Don quite literally gives the viewer a path into the scene. Notice how trees in the foreground have more detail and how Don simplified background trees by using strong silhouette shapes and patterns of light.

⋒ DON LOW
Lunching While Overlooking Some Rice Padi Fields, Bebek Tepi Sawah, Bali, Indonesia

5⅞" × 16½" | 15 × 42 cm; ink (brush pen) and watercolor.

In this scene, Laurie draws the viewer in with a pathway created by the river cutting through the forested habitat. Notice how patterns of light and shadow pull your eye towards the place where water, forest, and sky meet in the lower middle portion of the sketch.

⋑ LAURIE WIGHAM
Albion River, Near Mendocino, California, USA

15" × 11" | 38.1 × 27.9 cm; watercolor.

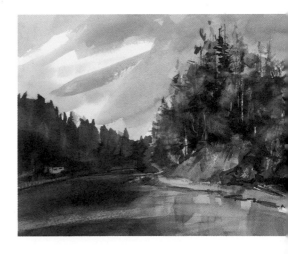

Arid Environments

Many people think of the arid environment of a desert as a barren, lifeless place. But the desert is home to plants and animals that have adapted to its extremes of temperature. It can be a place of extreme beauty with vast open spaces, rock formations sculpted by erosion, and a rich range of earth colors changing with the time of day. These dramatic sites create wonderful sketching opportunities.

Sometimes you find an unexpected spot of color, such as a cactus flower signaling spring in the desert, that invites you to slow down and take time to study it.

⌂ VIRGINIA HEIN
Desert Vignette,
Mojave Desert, California, USA
8¼" × 7¼" | 20.9 × 18.4 cm;
pencil, watercolor, and gouache.

⟳ VIRGINIA HEIN
Mittens Panorama (concertina sketchbook), Monument Valley, Arizona, USA (photo)

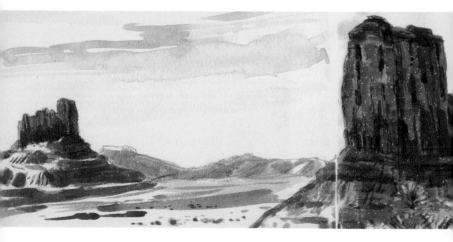

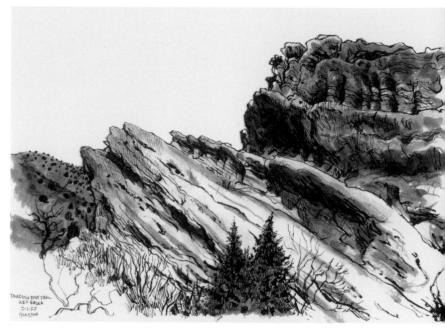

Paul's calligraphic ink line and gray washes beautifully describe the sculptural forms and craggy, weathered textures of these rocks. Forms and textures can be especially dramatic in the desert, with the intense clarity of light.

⦿ PAUL HEASTON
Red Rocks, Red Rocks Park,
Morrison, Colorado, USA
8" × 12" | 20.3 × 30.5 cm; fude fountain
pen and diluted ink wash on hot press paper

"In this sketch of Monument Valley, I chose a wide panoramic view, trying to convey the starkness of these red buttes rising up from the desert floor and the sense of vast distance between them. You can see the effect of atmospheric perspective in the soft blue of the distant mountains." —VH

☾ VIRGINIA HEIN
Mittens, Monument Valley Navajo Tribal Park,
Utah-Arizona border, USA
16" x 5" | 40.6 x 12.7 cm; pencil and watercolor.

The Nature of Water

Water's changeable nature and many forms make it challenging for sketchers. How you draw or paint water is all about movement—whether it's small ripples; a fast-moving flow; or glassy, reflective stillness.

Gary captures the slight movement of the water interrupting the reflection. You can see the ripples vividly reflect parts of the sky and surrounding foliage.

⊃ **GARY GERATHS**
Secret Sierra Canyon Beaver Pond,
Eastern Sierra Nevada, California, USA

8" x 6" | 20.3 x 15.2 cm; gouache.

Figure A

Figure B

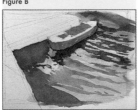

Figure C

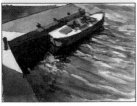

⊂ **GAIL L. WONG**
Water Demo, Rotterdam, The Netherlands

5" × 6½" | 12.7 × 16.5 cm; watercolor.

Painting Water Movement

Gail's sketches show her three stages to paint the slight movement and reflections within rippling water.

Figure A. The first pass uses bright, high key base colors painted with a wet-on-wet technique. You see the suggestion of the boat color in the water as well as shadows darkening certain areas.

Figure B. The second pass starts to add in the darker parts of ripples and shadow areas. Areas where Gail left the first layer unpainted create the light areas of the water ripples.

Figure C. Gail completes the scene with deeper shadows in darker areas. Light, transparent glazes of blues and yellow greens give a cool cast to the water in shadows and warmth to the water in brightly lit areas.

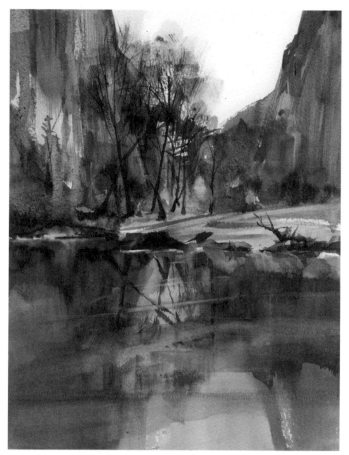

You can see the absolute stillness of the water in Laurie's painting. It is like glass mirroring the scene around it, with just the slightest ripples interrupting the perfect reflection, whose forms are slightly softened and muted.

⋂ LAURIE WIGHAM
El Capitan and Merced River,
Yosemite Valley, California, USA
11" × 15" | 27.9 × 38.1 cm; watercolor.

Tips

When painting still water, plan out your reflection. It is essentially a mirror image of the scene above, though slight ripples may interrupt it. Place the dark and light areas of shapes and colors directly beneath the image they reflect. Ripples in the far distance appear smaller and narrower than the ripples that are closer to you. This is the same effect that perspective has on objects that are far versus near. Water reflects the colors around it: the blue of the sky, the green of foliage, or the white of the clouds. However, reflected colors are often less saturated, with broken edges that are softer and less detailed.

Moving Water

You can find water moving in waterfalls, streams, shorelines, or in an urban setting—fountains, dams, and other water features. You can represent the movement in a variety of ways using a range of media. These three artists demonstrate three different approaches to conveying moving water in a sketch.

Suhita uses a toned gray paper for this sketch. To achieve the foamy white highlights in the waterfall, she paints splashes of white and adds white crayon. Notice how dark shadows behind the water visually push the white of the waterfall forward.

➲ SUHITA SHIRODKAR
Uvas Canyon Falls,
Uvas Canyon, California, USA
7" × 5" | 17.8 × 12.7 cm; watercolor and wax crayon on toned paper.

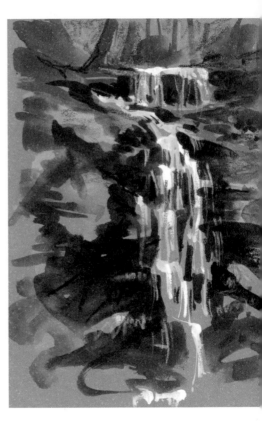

Tips

Hold yourself back from filling in every square inch with watercolor. Leave the white of the page to convey the bright highlights in moving water. To create contrast and suggest depth, use darks adjacent to the whites.

Suhita painted and drew bright white highlights onto her toned paper, while Paul used ink to follow the direction of rushing water with line and let the white of the page suggest foam. Eduardo's watercolor technique of using the white of the page to imply water takes some planning, but you can see how effectively it suggests the sparkle of water falling and reflecting the sun, especially when set off by dark painted areas.

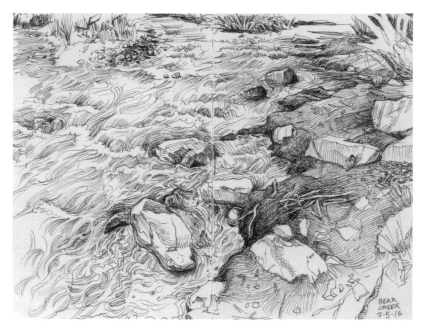

⌂ PAUL HEASTON
Bear Creek, Lair o' the Bear Park,
Jefferson County, Colorado, USA
5½" × 7" | 14 × 27.9 cm; *ink line.*

Paul's calligraphic line work describes a turbulent creek
with water swirling over and around the rocky bank.
Notice how the direction of line follows the direction of
water and dense lines create shadow areas. The white
of the page effectively conveys sunlight and foam.

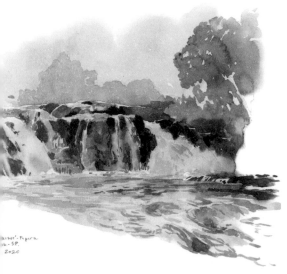

☾ EDUARDO BAJZEK
*Waterfall at Jacare Pepira
River,* São Paulo, Brazil

8¼" × 11¾" | 21 × 29.8 cm;
watercolor.

Water in Eduardo's
watercolor painting cascades
in waterfalls, then pools and
flows around the boulders
before tumbling down to a
lower stream.

Atmosphere and Weather

Atmosphere and weather can dramatically change the character of a place. A calm and peaceful sunny day can suddenly feel ominous and threatening with the onset of a storm. Changing conditions create opportunities to capture unique moments and atmospheric conditions. The sky is the dominant feature in describing atmosphere, as seen in these sketches of different weather conditions.

Duane's ink lines carve the shapes of clouds and describe the heavy downpour to capture the drama of a torrential New Mexico thunderstorm. Watercolor washes reinforce shadow shapes and the colors of distant mountains.

☿ DUANE BLOSSOM
Approaching Rainstorm,
Santa Fe, New Mexico, USA
6" × 8" | 15.2 × 20.3 cm;
ink and watercolor.

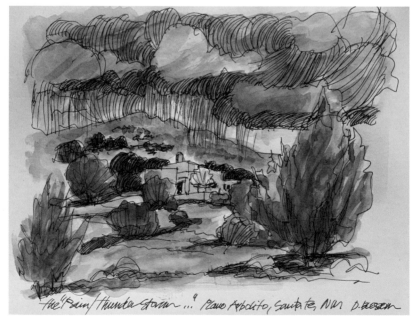

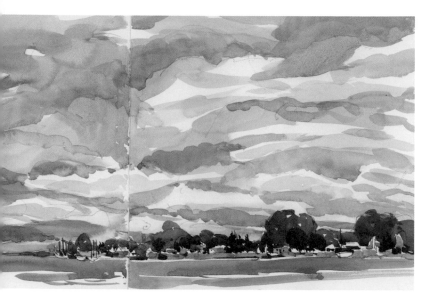

In Shari's painting of a turbulent sky, we see clouds moving and filling the space, overtaking patches of blue. Notice the warmth she added near the horizon line with a diluted wash of Raw Sienna. For the clouds, she began with a mix of Cerulean Blue and a tiny dab of Alizarin Crimson. Diminishing the size of the clouds as they approach the horizon adds perspective.

⌒ SHARI BLAUKOPF
Swirling Sky, Point Claire, Quebec, Canada
16" × 8" | 40.6 × 20.3 cm; watercolor and pencil.

Laura captures the fierce weather in this sketch while on a moving ship. Bold strokes communicate the stormy sky, rain, and rough seas, giving us a sense of a dramatic moment in time. Strong value contrasts, darkness of the clouds, and hard-edged, energetic strokes help to create the look of angry, threatening skies.

⊃ LAURA MURPHY FRANKSTONE
Norwegian Sea in December, Norwegian Sea
8½" × 11" | 21.6 × 27.9 cm; watercolor and colored pencil.

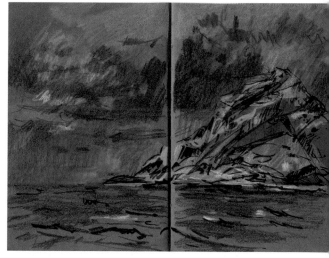

Skies and Clouds

Cloud studies can be fun and give you an opportunity to practice painting them before going out and painting a full scene. Gail quickly painted the studies below as she observed the passing clouds.

Figures A, D, and F show a wet-on-wet technique, in which you add pigment to a wet surface. First, paint the paper with a clear wash. After reducing excess water in the brush, dip it directly into your color pigment and apply the pigmented brush to the wet surface (Steps 1, 2 and 3). With this technique, be sure your brush is drier than the surface of the paper to avoid "blooms." In other words, do not re-dip your brush into water before making a stroke on the wet paper. Your paper contains all the water you need.

Figures B, C and G use a wet-on-dry technique. Here the paper is dry and you apply a wet pigmented brush to the watercolor paper, giving it the crisp, hard edges. You can add color to painted areas for a wet-on-wet effect in select areas.

Figure H uses a dry brush technique, where a drier brush with some pigment is applied to dry paper leaving irregular edges and strokes with areas that the paint skips over.

Figure A

Figure C

☉ GAIL L. WONG
Cloud Study on Location,
Seattle, Washington, USA
Various sizes; direct watercolor.

Figure B

Figure D

Figure E. Wet-on-wet

Figure F. Wet brush strokes on dry surface

Figure G. Dry brush strokes on dry surface

Figure H

Brushes and Techniques

Painting the ephemeral quality of clouds and large expanses of sky depend on techniques that allow you to cover a broad area with paint in the fewest number of strokes. To do that on big sheets of watercolor paper you may need large, flat brushes, as in Figure H.

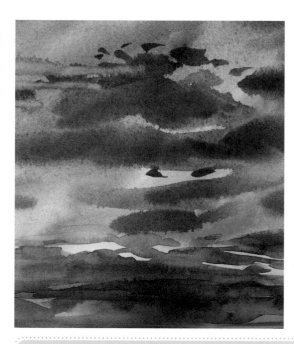

Kris's bold use of vibrant color and contrasts suggest the sky at sunset with clouds overhead. She uses primarily wet-on-wet technique here with some areas of the painting surface dry, creating a few hard edges for contrast.

☾ KRIS WILTSE

Sunset Storm, Clinton, Washington, USA

7" × 8" | 17.8 × 20.3 cm; direct watercolor.

Tip

Although it is tempting to paint on them, leave large areas of the white unpainted for clouds. The sky is the negative space you are painting around the cloud's forms. Cut the sky color into the white of the page leaving enough white visible for clouds.

Wet-on-Wet Technique

For a wet-on-wet technique, start by painting a clear wash over the paper. After reducing excess water in the brush, dip directly into your color pigment and apply the pigmented brush to the wet surface. With this technique, be sure your brush is drier than the surface of the paper to avoid "blooms." In other words do not re-dip your brush into water before making a stroke on the wet paper. Your paper contains all the water you need.

Step 1. Paint Naples Yellow on wet surface to create a golden glow.

Step 2. While still wet, add dark pigment for the cloud shade side.

Step 3. Paint sky around the clouds, leaving the white of the cloud.

Quality of Light

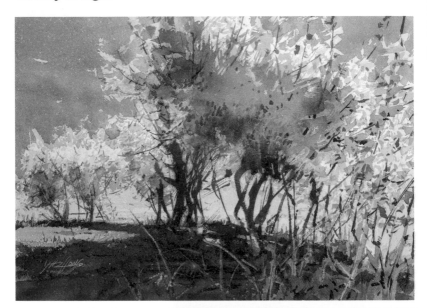

Yong captures the feel of early morning light as it illuminates these forsythia bushes. The plants seem to glow and the cast shadows convey the low angle of the sun. The lighter background against the contrasting dark value in the foreground creates this backlighting effect.

⌂ YONG HONG ZHONG
Golden Forsythia,
Lake Oswego, Oregon, USA
11" × 14" | 27.9 × 35.6 cm; watercolor.

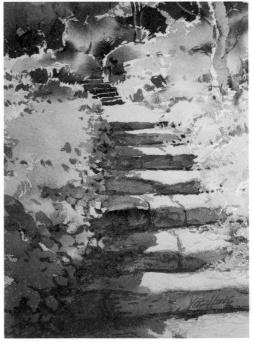

From late morning to noon, the sun shines brightly at a high angle, casting short shadows on the stairs. Notice that the colors in shadows are cooler than those in the sunstruck areas.

⟳ YONG HONG ZHONG
Early Spring,
Lake Oswego, Oregon, USA
12" × 9" | 30.5 × 22.9 cm; watercolor.

Time of day is key to understanding how light illuminates forms in nature and how that dramatically changes with the location and angle of the sun.

8:00 a.m.

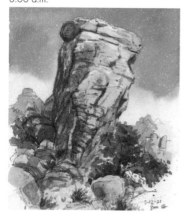

11:00 a.m.

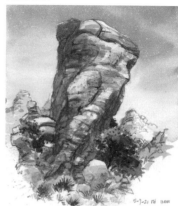

3:00 p.m.

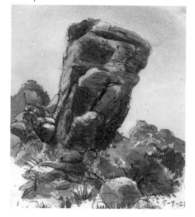

5:00 p.m.

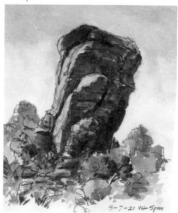

This towering rock in Joshua Tree National Park was the ideal location to study how light changes the appearance of forms and colors depending on time of day.

At 8 a.m., the bright sunlight illuminating the front and right side of the rock gives the granite a golden glow. As the sun moves higher in the sky, the light gradually comes directly from above. By 3 p.m., sunlight shifts to illuminate the left side, and by 5 p.m., the low-angle sun sharply lights the left side and casts the rest of the rock face in a deeper, contrasting shadow.

Sky color also changes through the day, with brilliant blue behind the rock in the morning fading to softer and warmer color later in the day.

◑ VIRGINIA HEIN
Four Studies of Hidden Valley Rock, Joshua Tree National Park, California, USA
9" × 11" | 22.8 × 27.9 cm
(each study); pencil and watercolor.

The Seasons

The natural world marks the seasons with changes in the environment—temperature, weather, and daylight hours—rather than the calendar. Depending on where you are, flowering plants announce spring, and there isn't a more reliable sign of seasonal change than the annual cycle of deciduous trees.

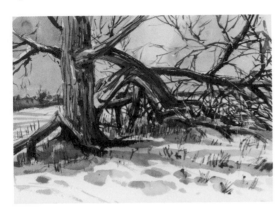

A field of sunflowers facing the sun is a sure sign of summer in many places. Notice how Barbara brings that golden yellow into the background foliage as well, giving a warm, golden light to this sketch.

⊃ **BARBARA TAPP**
Family Dreams,
Winters, California, USA
7" × 15" | 17.8 × 38.1 cm;
watercolor on cold press paper.

Shari's sketch communicates winter mood through the brittle barrenness of the tree and the cool blue shadows cast in the snow on the ground.

⋂ **SHARI BLAUKOPF**
Crack, Beaconsfield, Quebec, *Canada*
14" × 10" | 35.6 × 25.4 cm;
watercolor and pencil.

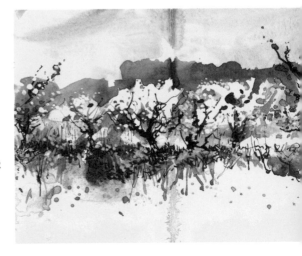

Suhita sketches blossoming trees in a mustard field with fresh, spontaneous strokes that convey the energy of new life and color in spring.

⊃ **SUHITA SHIRODKAR**
Mustard Fields and Blossoming Trees,
Saratoga, California, USA
32" × 6" | 81.3 × 15.2 cm;
(accordion-fold sketchbook) pen, ink, and watercolor.

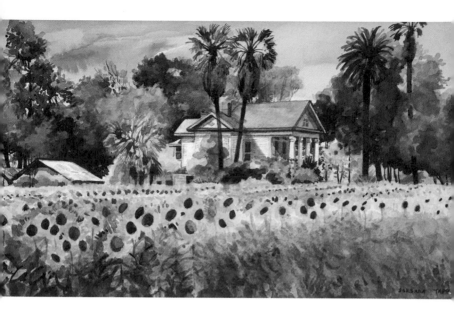

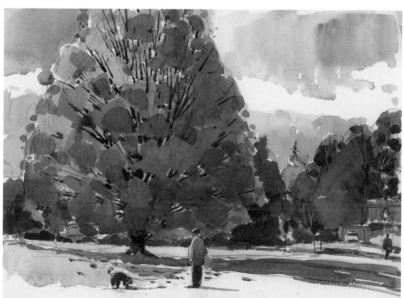

As fall colors reach their full splendor in Canada, Shari captures the changes of the season in her neighborhood. Notice how effectively foliage is simplified here, with the delicate branches providing support.

⌒ SHARI BLAUKOPF
My Favorite Tree,
Beaconsfield, Quebec, Canada
14" × 10" | 35.6 × 25.4 cm;
watercolor and pencil.

Snow and Seasonal Changes

Changes in seasonal weather and temperature affect how we see color. A blanket of snow can completely transform a familiar landscape.

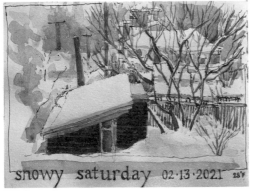

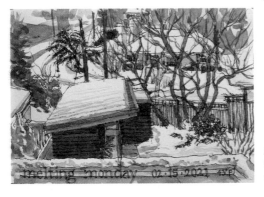

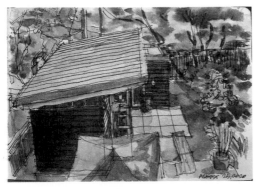

◖ GAIL L. WONG

Snowy Saturday,
Melting Monday,
DADU in Summer, Seattle,
Washington, USA

5" × 8" | 12.7 × 20.3 cm (each image);
ink and watercolor.

On a cold, overcast snowy day in Seattle, Gail shows us everything in variations of grays and white. Snowflakes in the sky shorten the range of visibility. Remember, do not paint the snow; instead, paint the shadows and objects you can see. Leave the white of the page to represent the snow.

As the snow melt happens and the temperature rises to create a thaw, we see subtle colors slowly emerge.

In the summer, bright saturated green hues have returned. The sun's back lighting coming through the leaves heightens the exaggerated colors.

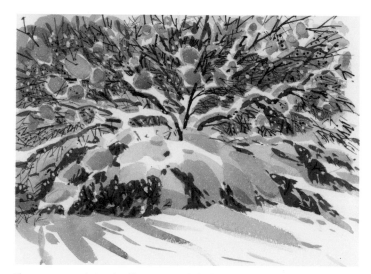

The snow-covered plant, backlit in morning light, has a sparkly glow. This, along with the blue shadows cast on the snow-covered ground, gives the sense of a sunny winter morning.

◯ SHARI BLAUKOPF
Snowballs, Beaconsfield, Quebec, Canada

8" × 11" | 20.3 × 27.9 cm; watercolor and pencil.

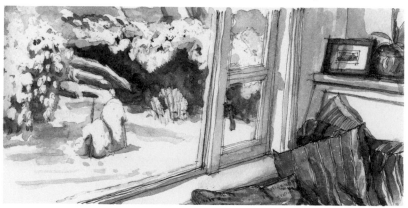

◯ GAIL L. WONG
Winter View from Window Seat,
Seattle, Washington, USA

6" × 12" | 15.2 × 30.5 cm; ink and watercolor.

Tips

Painting a snow scene is an opportunity to practice negative painting. You will paint shadows, shade—anything but the snow. The white of the page becomes the snow. You can create smaller specks of snow by painting dots with white gouache or using a white gel pen. You can also use a masking fluid to save areas that you want to keep white.

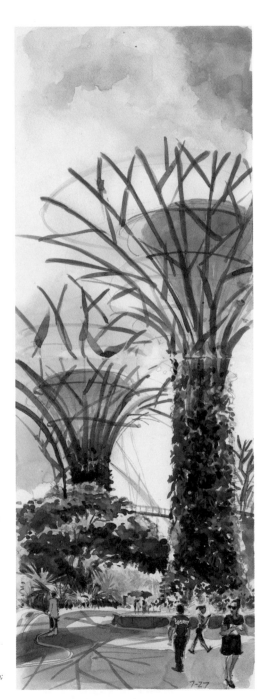

A view of the Supertrees, in Singapore's Gardens by the Bay, feels like a glimpse into the future. These massive vertical gardens generate solar power, collect rainwater and moderate temperature.

⊃ VIRGINIA HEIN
Supertrees (cropped view), Singapore

23" × 8¼" | 58.4 × 20.9 cm; pencil and watercolor.

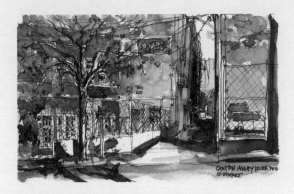

KEY IV
FINDING NATURE IN THE CITY

Where can you find nature in a city? Whether it's a planned and cultivated public garden, a little urban oasis of green, or growing wild in a vacant lot, nature takes hold in just about any urban setting. Nature in the city can be a large presence, such as a venerable landmark tree, understated shrubs planted to soften the edges along roads and highways, or a humble dandelion growing in a sidewalk crack. On a windowsill, a balcony, or in a backyard, we need and find places to grow things and observe nature.

○ GAIL L. WONG
Canton Alley, Seattle, Washington, USA
5" × 8" | 12.7 × 20.3 cm; ink and watercolor.

Finding Nature in the City

Natural elements can soften the hard edges of concrete, metal, and glass that make up a city's manmade environment. Nature can create context or become the focus in a sketch of the city.

Frank uses a conifer planted along the sidewalk to frame a side of the upward-facing view of an atrium-covered street.

⊃ FRANK CHING
Washington State Convention Center,
Seattle, Washington, USA
10" × 7" | 25.4 × 17.8 cm; ink.

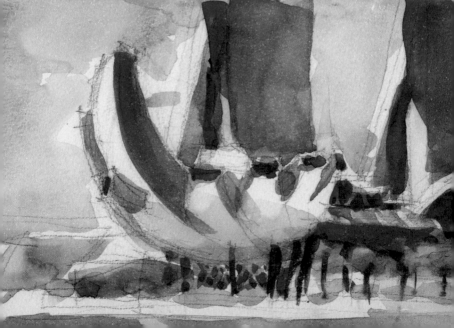

Virginia finds nature in the city of Los Angeles in the gap between two buildings.

➲ **VIRGINIA HEIN**
Kaiser Sunset Towers, Los Angeles, California, USA

15" × 6" | 38.1 × 15.2 cm; pencil, watercolor, and gouache.

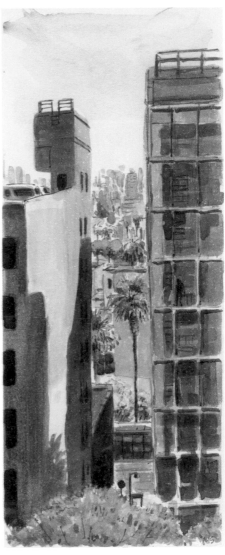

In Gail's sketch, the trees along the water's edge provide ample cool shade in the hot, humid climate of Singapore. They also create a color contrast to the white of the concrete and glass structures of the Marina Bay Sands hotel and the lotus flower-shaped ArtScience Museum.

☾ **GAIL L. WONG**
Marina Bay Sands, Singapore

6" × 12" | 15.2 × 30.5 cm; pencil and watercolor.

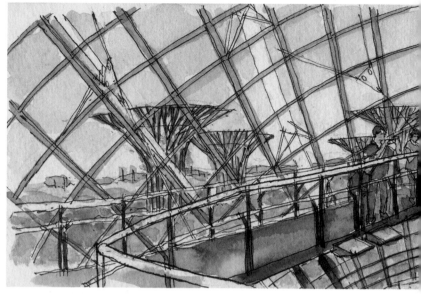

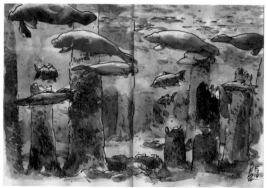

Don captures the freshwater environment of these manatees at a gigantic aquarium in Singapore. Notice how the play of light and shadow creates a sense of depth and dimension as the light coming from above the water's surface draws your eye.

C DON LOW
Watching the Manatees, River Safari, Singapore
7⅞" × 11¾" | 21 × 30 cm; ink and watercolor.

Even in a large city, you find opportunities to sketch nature. Singapore is known as the "Garden City," and despite its compact size it has green spaces throughout, from roof gardens to grand scale biodomes. You can find public parks in just about any city.

Workshop

Beyond your own garden, you can find collections of plants and wildlife in arboretums, conservatories, public gardens, river walks, parks, and zoos. Take those opportunities to sketch nature within your city.

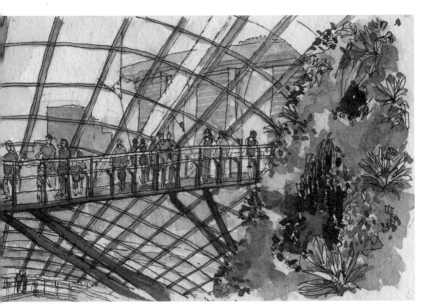

Gail found nature in this enormous climate-controlled environment, a conservatory at Gardens by the Bay in Singapore. It is a welcome respite from the humid heat outside. The view through the dome windows shows the Supertree Grove outside.

�609 GAIL L. WONG
View from the Cloud Dome,
Gardens by the Bay, Singapore
16" × 5" | 40.6 × 12.7 cm;
ink and watercolor.

In Tia's sketch of Singapore's Ginger Garden, we see the lush variety of ginger plants surrounding a pool of giant Amazon water lilies. We get a sense of grand scale with the "Little Girl on a Swing," the life-sized bronze sculpture on the right. Notice how Tia simplified the background with gestural lines and lush color.

�609 TIA BOON SIM
Ginger Garden, Botanic Garden, Singapore
33¼" × 10¼" | 84.5 × 26 cm;
ink and watercolor.

Connecting with Nature in the City

There are many ways we can engage with nature when we are in the city. A public park, a shady square, or a small green space can be an opportunity for play or reflection. It can be a place of shelter or simply a place to touch and interact with nature.

For a sketcher, it's an opportunity to sketch people at their most relaxed and to add the human element to a location sketch. When looking at a scene with people, the human presence tends to draw the eye. As you begin your sketch, consider whether your main character is the environment, the people, or the interplay of the two.

On a day of record-breaking heat, people find shelter under shade trees in a small public square in Amsterdam. This shady square is a respite from the large, open Rembrandtplein nearby. Sometimes we need to go off the beaten path to find nature in a large city.

⊙ VIRGINIA HEIN
Thorbeckeplein, Amsterdam, The Netherlands
18¾" × 12¼" | 47.6 × 31.1 cm; ink and watercolor.

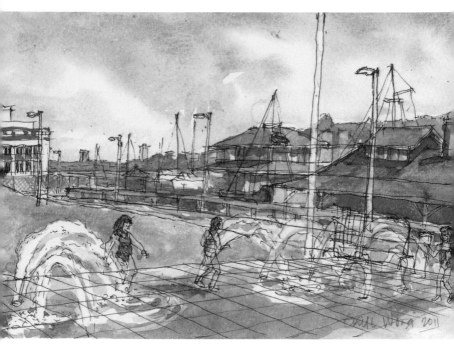

On a sunny summer day in Seattle, kids run through fountains and play in the park. The white of the paper sparkles as the fountain spray. Vibrant blue shadows throughout unify the composition and help convey the sense of bright sunlight.

⋂ GAIL L. WONG
Summer Play at Mohai, Seattle, Washington, USA
6" × 12" | 15.2 × 30.5 cm; ink and watercolor.

Echo Park Lake is a true urban oasis, with a view of the downtown Los Angeles skyline. Geysers shoot up from the middle of the lake, surrounded by people in paddle boats. When working on a toned paper, add the light; Virginia used white gouache for the bright spume of water.

⋑ VIRGINIA HEIN
Echo Park Boats, Los Angeles, California, USA
9" × 8½" | 22.8 × 21.6 cm; pencil, watercolor, and gouache on toned paper.

Random Nature

Especially in urban areas, nature often finds its way into unexpected places. It fills spaces previously inhabited by something else or simply grows untended on some abandoned patch of ground. Sometimes it's the spaces in between, the overlooked landscape, that offers you the greatest opportunity to bring your own point of view to the subject.

Nina reveals beauty in this patch of green growing out of an old car at the Båstnäs Car Cemetery.

◒ NINA JOHANNSON
Volkswagen Ecosystem,
Värmland, Sweden

*10" × 7¾" | 25.4 × 19.7 cm;
ink and watercolor.*

Tip

Find a random "volunteer" plant or grouping of plants in your neighborhood to sketch.

You could easily pass by this patch of foliage without really noticing it. When Fred went looking for his grandfather's family home, what he found was "a tangle of weeds and a tangle of power lines to match. So often I find that an interesting composition can somehow turn nothing into something worth seeing."

↻ **FRED LYNCH**
Newark Street, Providence, Providence, Rhode Island, USA

10" × 8" | 25.4 × 20.3 cm; brown ink and pencil.

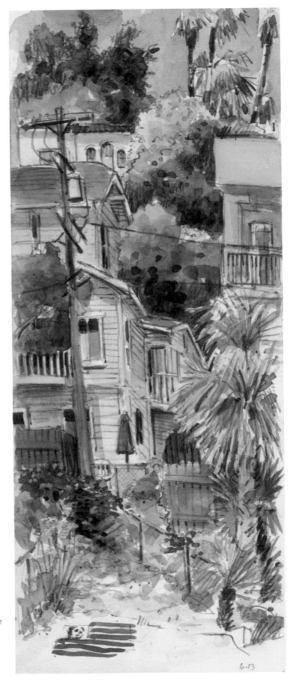

Along a less glamorous stretch of the famed Sunset Boulevard, an eclectic collection of houses on a hill appears stacked on top of each other.

↻ **VIRGINIA HEIN**
Stacked Houses, Los Angeles, California, USA

14¾" × 6" | 37.5 × 15.2 cm; pencil and watercolor.

"I was intrigued by the space between the houses—a lush, jumbled mix of intentional gardens and random weeds." —VH

Finding Nature Close to Home

A gathering of plants can become a garden, wherever you are. A small patio, a balcony, or a quiet courtyard can be a refuge; a place for quiet, focused study of nature. We can find nature everywhere and anywhere. Especially in an urban environment, people find a way to bring nature close to them.

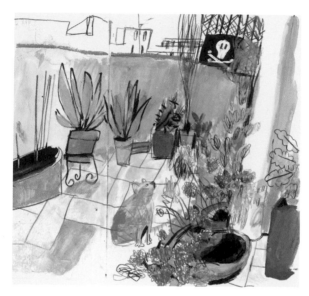

Inma created this charming scene on her home terrace during lockdown. What she says sums up what so many felt during this time: "We have been at home for seven days without being able to leave, due to the pandemic. At least we can breathe the spring on the terrace."

☾ INMA SERRANO
Lockdown, Day 7,
Seville, Spain

11⅜" × 16½" | 29.7 × 42 cm;
ink and watercolor.

Lapin found a quiet spot in a botanical garden to make a careful study of the intricate structure and delicate colors of these cacti and succulent plants.

➲ LAPIN
Jardins de Mossèn Costa i Llobera,
Barcelona, Spain

6¼" × 16½" | 15.8 × 41.9 cm;
fine liner, watercolor, colored pencils, and gel
pen on a second-hand accounting book.

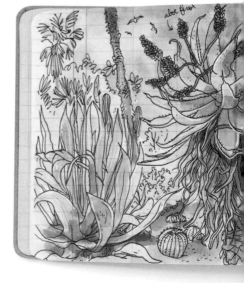

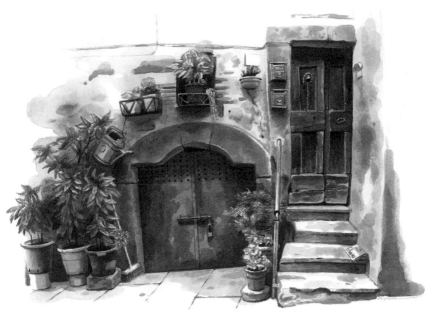

♫ FRED LYNCH
Bagnaia Flowers,
Bagnaia, Italy

*11" × 15" | 27.9 × 38.1 cm;
brown ink and pencil.*

"I've wandered the narrow streets of towns like this for years, stopping to capture on paper things that strike my fancy. In this case, I loved the gathering of all these plants around this ancient house's doors. As I drew, a group of old ladies sat and gossiped nearby. They gathered similarly to these plants, actually. I can't speak much Italian, but I'm sure that they expressed their surprise at how such an ordinary scene for them was seen as extraordinary to me." —Fred Lynch

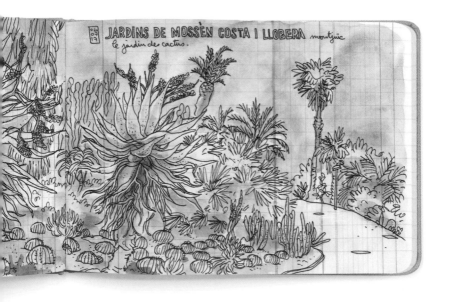

Paul explores a variety of approaches to sketching a pear, showing us that there are multiple ways to represent a natural object.

⌒ PAUL WANG
Pears No. 1, Singapore
7⅞" × 7⅞" | 20 × 20 cm; ink, pencil, colored pencil, and watercolor.

KEY V
MORE WAYS TO REPRESENT NATURE

Every medium has its own unique qualities and character. Here, we look at how different media and approaches are suited to express distinctive aspects of nature. You will see how you can combine materials effectively in a sketch, and look into different ways of thinking about color. Color in nature can be surprising and unexpectedly varied.

We also look at ways you can be free to interpret your observations of nature and move from literal representation to more expressive and abstract forms—seeking the essence of your subject or a playful interpretation.

⊙ **VIRGINIA HEIN**
Japanese Garden Quartet,
La Cañada, California, USA
11" × 11" | 27.9 × 27.9 cm; pencil,
watercolor, gouache, and pigment powder.

Sketching in Monochrome

Monochrome can effectively evoke the atmosphere of a place, with nuances of light and shadow, depth, and texture. Using a range of values from light to dark, you can focus on seeing patterns of light and shadow in your subject. This can sometimes be hard to do when you are working with full color. Many artists feel that values are the foundation of making a successful drawing or painting.

Virginia made this monochromatic, direct watercolor sketch to study the morning light and atmosphere. It also gave the opportunity to simplify the range of values as you can see in her value scale.

⊃ VIRGINIA HEIN
Echo Park Palm in Monochrome, Los Angeles, California, USA
10¾" × 9" | 27.3 × 22.9 cm; direct watercolor.

Fred uses brown ink washes to build a rich range of lights and darks in these statuesque umbrella pines. Using a monochromatic palette, he was able to render the effects of age and weather on a medieval wall.

☾ FRED LYNCH
The Trees by Porta Fiorentina, Viterbo, Italy
15" × 11" | 38.1 ×27.9 cm;
brown ink and pencil on watercolor paper.

Tip

When working in monochrome, try simplifying to the use of three to five values, from the lightest light to the darkest dark. This helps you see the essential shapes and values in your subject.

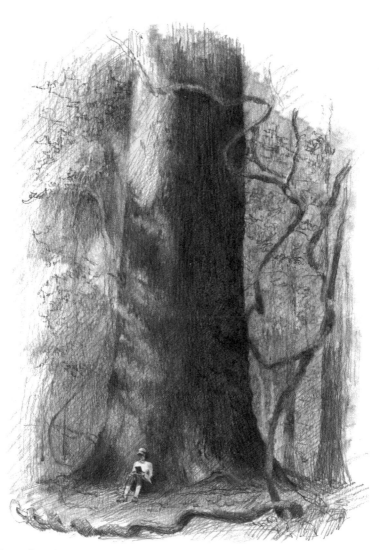

The human figure here dramatizes the sheer massiveness of this tree. Eduardo's sensitive pencil rendering focuses our attention on its form, texture, and solid presence. The accompanying grayscale simplifies the values, from light to dark.

◑ EDUARDO BAJZEK
Brazil Nut Tree, south border of the Amazon Forest, Brazil

11½" × 8¼" | 29 × 21cm; pencil.

Harmonious Palettes

You are likely familiar with a basic color wheel, with the primary colors being yellow, red, and blue. This double color wheel shows two different versions of those primaries: cool on the inner wheel and warm on the outer wheel. Notice the difference in the mixed colors. The hues on the outer wheel give you warm, earthy colors, while the inner wheel mixes brighter, more saturated hues. It is useful to know how colors mix when it comes to painting the colors you see in nature.

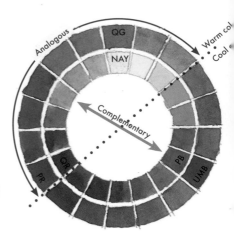

Complementary colors are opposite each other on the color wheel. Using them in a sketch creates contrast and balance. Using analogous colors (hues adjacent on the color wheel) tends to create color harmony.

Inner Wheel
NAY –Nickel Azo Yellow
QR –Quin Rose
PB – Phthalo Blue

Outer Wheel
QG – Quin Gold
PR – Pyrrol Red
UMB – Ultramarine Blue

In *Red Collection*, Nina uses an analogous color palette of colors in and adjacent to the red family. Accents of green, red's complement, spark the predominantly red palette.

☾ **NINA KHASHCHINA**
Red Collection,
Mountain View,
California, USA

10" × 7" | 25.4 × 17.8 cm; watercolor.

Analogous Colors

Santi often includes his color palette in his sketch. You can see he uses analogous colors ranging from warm yellow greens to cool blue greens in this piece.

⊃ SANTI SALLÉS

Cuitadella Park, Barcelona, Spain

11¾" × 8¼" | 29.8 × 21 cm; oil-based pencil, pen, watercolors, and colored pencils.

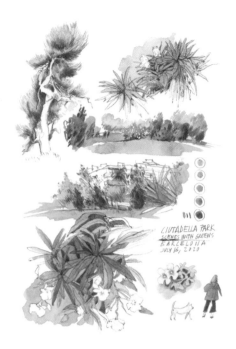

Complementary Colors

Paul uses complementary colors in this sketch. Combining opposite colors on the color wheel can create contrast, but also mixing them in varying amounts can give you a rich visual harmony and balance. Mixing a color with its complement can neutralize a potent color where the hue is too strong.

☉ PAUL WANG

Baobab Trees, Flower Dome, Gardens by the Bay, Singapore

10¾" × 7" | 27 × 18 cm; watercolor, pencil, and colored pencils on hot press watercolor paper.

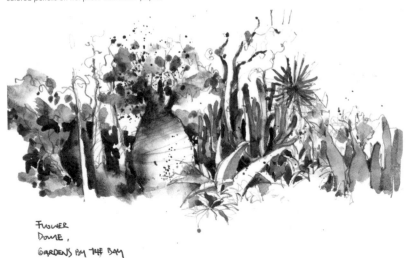

Colors of Your Location

Depending on where you are, it is likely that you see certain colors frequently in foliage. You can create a regional palette that reflects the plants thriving in the climate of your locale.

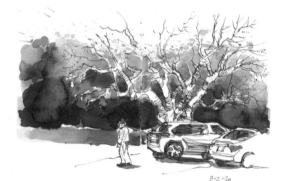

Virginia mixes four colors—Nickel Azo Yellow, New Gamboge, Quinacridone Gold, and Indigo Blue—to get this warmer foliage palette.

☾ VIRGINIA HEIN
Parking Lot Tree,
La Cañada,
California, USA
8" × 11½" | 20.3 × 29.2 cm;
ink and ink washes.

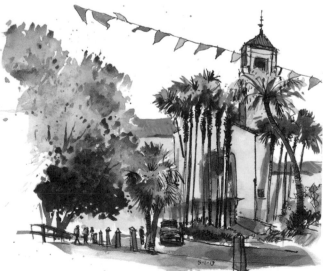

In Southern California, Virginia responds to the warm yellow greens she sees in nature around her. These colors convey the arid heat of the region.

☾ VIRGINIA HEIN
Union Station,
Los Angeles,
California, USA
11" × 13½" |
27.9 × 33.7 cm;
ink and watercolor.

Gail mixes four colors—Nickel Azo Yellow, Transparent Pyrrol Orange, Phthalo Blue, and Ultramarine Blue—to create the cool foliage palette.

⊃ **GAIL L. WONG**
Washington Park Arboretum,
Seattle, Washington, USA

7" × 10½" | 17.8 × 26.7 cm;
direct watercolor.

Gail's palette reflects the cool greens she sees in the Pacific Northwest. You can feel the cool, moist climate of this locale through these colors.

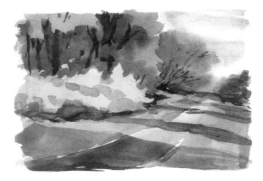

↻ **GAIL L. WONG**
Seattle Chinese Garden,
West Seattle, Washington, USA

8" × 10" | 20.3 × 25.4 cm;
direct watercolor.

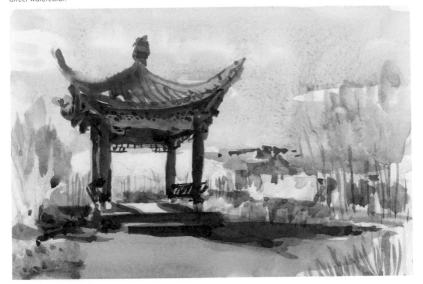

Experimenting with Texture

There are a variety of ways to create different textural qualities in a watercolor sketch. You can have a lot of fun experimenting with materials such as salt crystals, which absorb water in interesting patterns when sprinkled on wet paper. You can also achieve a variety of effects with different brushes and natural sponges. Certain watercolor pigments, such as natural earth colors, are known for their granulation, leaving the pigment to settle into the crevices of a textured paper. These paints will naturally create a surface texture in your sketch. This is what we mean when we say, "let the watercolor do its magic."

A. **Hake Brush** Perfect for painting large areas of wash with smooth, even strokes

B. **Fan Brush** Makes a series of lines with one stroke, useful for things such as wood grain

C. **Stencil Brush** Great for spattering paint

Rock salt crystals

Rock salt crystals on wet paper

Wet-on-wet with hake

Sponge and spatter

Fan brush using dry-brush technique

Sponge texture

Layers of spattering

Natural Sea Sponge

⋂ **MÁRIO LINHARES**
Pebbles, Lisbon, Portugal
10¼" × 14½" | 26 × 37 cm; watercolor.

Mário collected these lava pebbles with white quartz lines while in Sicily. He creates the granulating colors by mixing each color to contain all the colors seen in the pebble, then paints slowly to allow pigments to settle evenly on textured paper. He uses different watercolor brands, which add to the effect.

"Because [the various watercolor brands] had different ingredients, they don't settle down on the paper completely mixed, and that creates an interesting outcome." —Mário Linhares

Workshop

Choose a simple subject with an interesting variety of textures; a small arrangement of stones, weathered bark, or a dry leaf is ideal. With simple forms you can focus on the surface textures. Try some of the techniques and materials you see here. If you try using rock salt, you may want to use different-sized crystals for variety. You can do spattering with any kind of stiff brush, but the stencil brush or an old toothbrush makes it a bit easier to direct the spatter. Natural sea sponges come in a variety of sizes and there are no two alike. Hake brushes also come in all sizes. The most important thing is to keep a spirit of experimentation when you do this, because the results will be unpredictable—that is part of the fun!

Simplify with Notan

Notan is a Japanese concept that means the harmony of light and dark. It is a great way to practice seeing the patterns of light and dark in your scene and composing them in your sketch.

A detailed or colorful scene can overwhelm the eye. Making Notan studies can help you to discern and simplify the organization of big shapes and patterns and lead you to a better composition. The "Artist's Squint" is a great way to see these patterns in the scene: Lower your eyelids to let in less light and you will see less color and more value contrast.

Notan studies push you to simplify your black and white decisions. You decide what will go toward the dark values (black) and what will go toward the light values (white). This allows you to see forms and shapes of your composition.

↻ VIRGINIA HEIN
6 Japanese Garden Notans,
La Cañada, California, USA
10" × 3½" | 25.4 × 8.9 cm;
Japanese fude brush pen.

↻ VIRGINIA HEIN
Japanese Garden in Grays,
La Cañada,
California, USA
11¾" × 9" | 29.8 × 22.9 cm;
ink and watercolor.

The photo has a lot of detail and a range of values. Try squinting your eye to see if patterns of light and dark start to emerge.

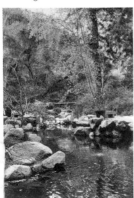

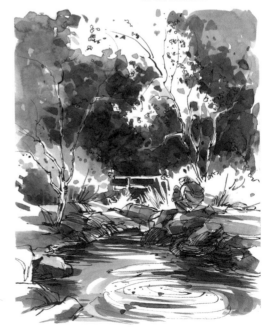

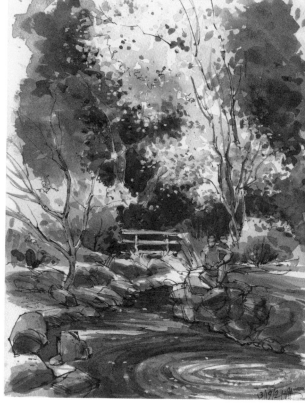

⊃ **VIRGINIA HEIN**
Flowering Cherry Tree,
La Cañada,
California, USA

12" × 9" | 20.5 × 22.9 cm;
ink and watercolor.

"In the grayscale sketch (left), I expanded the range of values, and in
the color sketch (above), my goal was to highlight the cherry blossoms
with the pattern of deep shadows in the foliage around them." —VH

Workshop

Try simplifying a scene using Notan. Working thumbnail size (no larger
than a postcard) and working quickly will help you see those patterns
of light and dark and make choices in your sketch. Try the artist's squint
to help you see the darks and lights more distinctly. Try a few different
compositional ideas before you move on to a larger drawing. This will
help you establish a dynamic range of values as you develop a sketch
with color.

Simplify to Find the Essence

How much information do you need to communicate an idea or scene? Simplifying what you put on the page forces you to distill your scene down to its essence and leave more for the viewer to interpret. As Gail's examples illustrate, it can take several attempts to get there. When we move away from representational painting to more simplified shapes and values, we are free to interpret as we discover what is essential in the scene.

Washington Park Arboretum
Seattle, Washington, USA

Attempt 1
"Though I was aiming at a more abstract representation of the arboretum, my initial attempt at this watercolor replicated what I saw."
—GLW

Attempt 2
"In the second attempt, shape becomes a bit more general and simplified."
—GLW

Attempt 3
"Using a 1½-inch-wide (3.8 cm) angled flat brush, I made simple and broad strokes to create geometric, rectangular shapes. Color and value were interpretive, freeing me from the dictates of reality." —GLW

⊃ **GAIL L. WONG**
Washington Park Arboretum
(three attempts),
Seattle, Washington, USA
5" × 8" | 12.7 × 20.3 cm; *direct watercolor.*

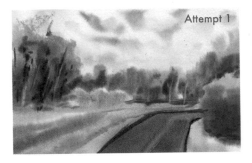

Attempt 1

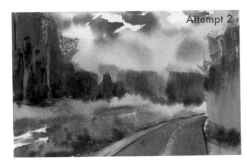

Attempt 2

Attempt 3

"To master simplification or when trying a new technique, studio studies are helpful prior to getting out on site. In this study, I used only large, flat brushes. This exercise forced me to create the simplicity of the image with the least number of strokes. One or two passes in areas using a wet-on-wet technique in the background, with some wet-on-dry strokes for the final passes." —GLW

⊃ GAIL L. WONG
The Beach at Cape Cod,
Cape Cod Study,
Massachusetts, USA

10" × 14" | 25.4 × 35.6 cm;
direct watercolor, 2⅖-inch-wide (60 mm)
and 3-inch-wide (80 mm) flat brush.

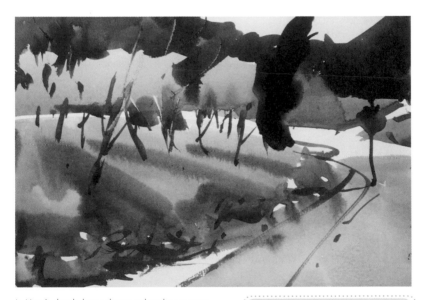

In Uma's sketch, large directional strokes convey the perspective of mustard rows and the direction of wind. Big brushes not only force simplification, but "also trick the viewer into finding a decluttered piece while giving more information."

∩ UMA KELKAR
Spring Rounds the Corner,
Morgan Hill, California, USA

8½" × 11" | 21.6 × 27.9 cm;
direct watercolor, 16 Round Brush or No. 4 Mop.

Tip

When you want to simplify, you've got to go big with the brush. Use large brushes that can cover large areas. Reduce the number of strokes you use. Work areas wet-on-wet when possible. Let the watercolor do its magic.

Allowing for Interpretation

In representing nature, have some fun! Interpreting what you see with your own unique point of view and style stamps your individual fingerprint on your sketch. These examples show how you can bring a fresh attitude and sense of playfulness to your sketches. What if you looked at a tree that you see every day as if you'd never seen it before? Or brought the fresh eyes of a curious child to the subject?

The tree on the left, fearlessly rendered in an unexpected hot pink, really grabs our attention. Notice how convincingly it shows the tree's texture and dimensionality. In the black-and-white sketch in the middle, Don developed the intricate texture of the gnarled tree into animated patterns. In the sketch at far right, Don shows us that nature can give us some very unexpected forms and colors, so why not exaggerate a little?

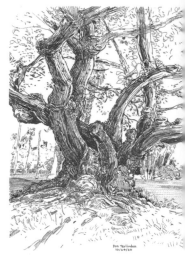

⋒ DON TERLINDEN
Pink Tree, Long Beach, California, USA

12" × 9" | 30.5 × 22.9 cm;
disposable colored fountain pens.

Workshop (Be Fearless!)

What if you look at something you see every day as if you'd never seen it before? Choose some natural element—it could be a familiar view, a tree or other plant, a hill, a pile of rocks. Make a careful study first, and then—loosen up! Try a small series of sketches with different approaches. Use unexpected colors, exaggerate the forms, make it an experiment and see where it takes you!

Judith made her first cactus sketch a careful study with naturalistic colors and forms. Her second sketch, made in about ten minutes, brings a wonderful sense of whimsy and fun to those same cactuses.

☾ JUDITH DOLLAR
Prickly Pear Cactus #1,
Central Texas, USA

8½" × 11" | 21.6 × 27.9 cm;
pencil, watercolor, and water brushes.

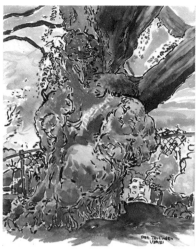

⋒ DON TERLINDEN
Black and White Tree,
Long Beach, California, USA

12" × 9" | 30.5 × 22.9 cm; black brush pen.

⋒ DON TERLINDEN
Gnarled Tree, Long Beach, California, USA

12" × 9" | 30.5 × 22.9 cm;
black brush pen and gouache.

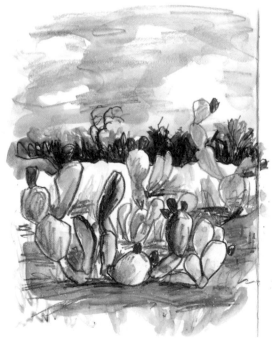

☾ JUDITH DOLLAR
Prickly Pear Cactus #2,
Central Texas, USA

7½" × 5½" | 19 × 14 cm;
water-soluble colored pencils
and water brush.

Maru's sketches are full of life and energy,
with bold strokes of color and layers of texture.

☊ **MARU GODAS**
*Guys Cycling around Stanford
Campus, Palo Alto, California, USA*
13⅝" × 12⅜" | 34.5 × 31.5 cm; gouache.

GALLERY
INSPIRED BY NATURE

Throughout this book, we talked about how to observe and represent nature. We believe that learning to see and practicing with tools and techniques is key to how you develop confidence in your skills and personal style. Let's look now at the work of artists who are clearly inspired by nature. While they closely observe it, they interpret what they see in a distinctly personal way. There's no limit to the range of media and approaches you can bring to the subject of nature, and we hope you will be inspired, too.

ᴖ **GAIL L. WONG**
Arboretum Abstract, Seattle, Washington, USA
10" × 14" | 25.4 × 35.6 cm; direct watercolor.

"As I was drawing this at the Bronx Botanical Garden, I was thinking of a dear friend who had died of cancer. The late-summer rose, beginning to drop its petals, was a reminder of the fleeting beauty of life." —Veronica Lawlor

➲ **VERONICA LAWLOR**
A Rose for Joe,
New York City,
New York, USA

8½" × 5" | 21.6 × 14 cm; fountain pen, brush pen, and water-soluble crayons.

➲ **VERONICA LAWLOR**
Cherry Blossoms Branch, New York City, New York, USA
11" × 8 ½" | 27.9 × 21.6 cm; pastel.

Veronica chose pastels as the medium for these two sketches because of their rich color saturation, perfect for the richly saturated color of the flowers. They also have an ephemeral quality, like these seasonal blooms.

➲ **VERONICA LAWLOR**
Peony, New York City,
New York, USA
11" × 8½" | 27.9 × 21.6 cm; pastel.

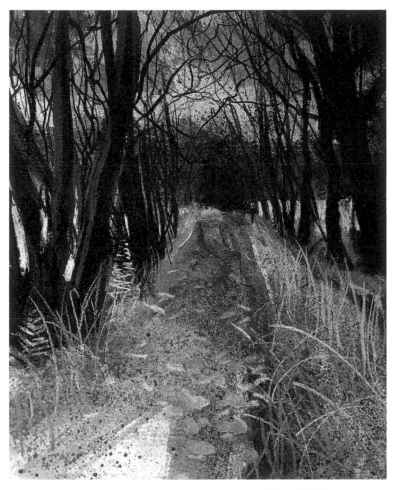

⋔ DAVID LOWTHER
Lakeside Trail, Combs Reservoir,
Derbyshire, UK

11½" x 8¼" | 29.2 x 21 cm;
gouache and pastel on watercolor paper.

"If I can get the feel of a scene as quickly as possible, then that's half the battle. It can be as simple as a few brushstrokes—in this case, one central block in black, then another, paler one for the sky—then I worked my way into it in colored pastel, adding highlights as I go, and finally adding the trees and undergrowth in white pencil, brush pen, and gouache." —David Lowther

Explorations

These artists created different representations of nature using various media and experimental approaches.

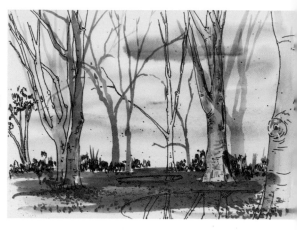

⊃ MÁRIO LINHARES
Gulbenkian Garden,
Lisbon, Portugal
*10¼" × 14½" | 26 × 37 cm;
mixed media.*

"A garden is a world of textures and colors, so using a mixed media technique to record this diversity is always a good option. I started with some watercolor washes for the background but it tends to turn a little pale after drying. Using colored pencils on top of the watercolor helps to accentuate the lights and shades. In the end, the darker tones help to show the shadows and the black pen line focuses the eye on some details." —Mário Linhares

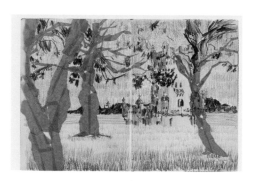

Grazielle created these drawings at one of the most famous spots in Lisbon: the Belém Tower.

⊂ GRAZIELLE B. PORTELLA
Before and After Tape (before),
Lisbon, Portugal
*16½" × 11¾" | 42 × 29.7 cm;
tape and pencil.*

"By registering nature around the tower with tape and then taking it out leaving just the blank branches, the goal was to call attention to other points of view which are not normally explored by urban sketchers who draw in this area."
—Grazielle B. Portella

⊂ GRAZIELLE B. PORTELLA
Before and After Tape (after),
Lisbon, Portugal
*16½" × 11¾" | 42 × 29.7 cm;
tape removed and pencil revealed.*

"Experimenting and exploring the chemistry of water and color. Imagine the colors like liquid, pour them slowly into the drawn objects like a vessel and watch them dance."
—Paul Wang

⊃ PAUL WANG
Onions, Singapore

9¾" × 6" | 25 × 15 cm; watercolor, pencil, and colored pencils on cold press watercolor paper.

⋂ PAUL WANG
Pears 2, Singapore

6" × 9¾" | 15 × 25 cm; watercolor, pencil, and colored pencils on cold press watercolor.

Ch'ng Kiah Kiean is noted for his calligraphic style of sketching with twigs and Chinese ink. He discovered that water-soluble graphite has similar working qualities as the ink and enjoys using it with pencils and watercolor.

⊃ CH'NG KIAH KIEAN
Tree at Jalan Taman Cantik,
Hye Keat Estate (right),
Penang, Malaysia

15" × 11" | 38 × 28 cm;
graphite and watercolor,
graphite on paper.

"As an artist, it is so common to be met with bottlenecks, whether in terms of media, format, or subject matter. I believe this to be the artist's challenge and daily homework. Every breakthrough should be celebrated, no matter how small or seemingly insignificant. The artistic journey is one that has to be taken alone, as no one is as sensitive to changes in your artworks as you."
—Ch'ng Kiah Kiean, English translation by Ryan Ng

⊃ CH'NG KIAH KIEAN
Wild Flowers Series I (right),
Penang, Malaysia

26" × 6½" | 66 × 16.5 cm;
graphite and watercolor on rice paper.

⊃ CH'NG KIAH KIEAN
Wild Flowers Series II (far right),
Penang, Malaysia

26" × 6½" | 66 × 16.5 cm;
graphite and watercolor on rice paper.

☺ INMA SERRANO
Mills in Alcalá, Alcalá de Guadaira, Seville, Spain

16½" × 11⅜" | 42 × 29.7 cm; mixed media: colored pencils, watercolor, gouache, acrylic markers, and ink.

"One of the first times that I have been able to enjoy group drawing after confinement. We had gone on a picnic to the Alcalá Park to draw the mills. The wonderful environment, the cool but clear day, and my friends. I cannot imagine a better plan for a Sunday. Enjoying small pleasures." —Inma Serrano

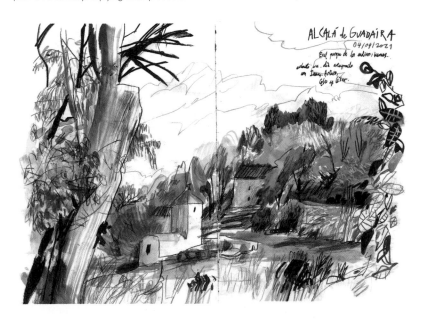

◐ MARU GODAS
Mar de Lira, Galicia, Spain
9⅝" × 25⅝" | 24.5 × 70 cm;
gouache and colored pencil.

"Plein air painting is one of the most beautiful experiences. It's an act of love where you put your emotions, space, and time at the service of your hands and your heart. When you review those drawings, you go back there, and you feel like you took a little piece of that place with you. Drawing is traveling, it's loving." —Maru Godas

◑ MARU GODAS
Shadowhouse of Ciutadella Park,
Barcelona, Spain
8 ⅝" × 10 ⅝" | 22 × 27 cm;
acrylic gouache on cardboard canvas.

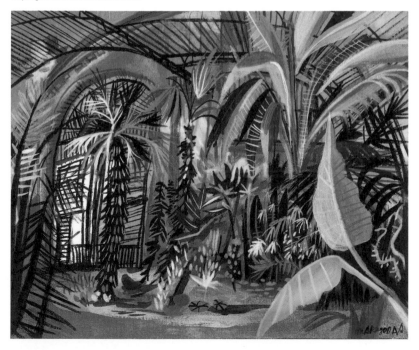

CHALLENGES

1. ☐ Sketch a tree that you've seen many times but never looked at closely.

2. ☐ Sketch a scene with foliage without using green: mix your greens with yellows, blues, and other colors.

3. ☐ Draw with a tool you've never used before.

4. ☐ Paint or add color to a sketch using the biggest brush you can find—does it help you simplify?

5. ☐ Sketch a scene at three different times of day—early morning, midday, and late afternoon. What do you notice?

6. ☐ Make a study drawing of a single flower or leaf. Look carefully at the shape and structure.

7. ☐ Sketch a close-up view of the base of a tree. How does it grow out of the ground?

8. ☐ Sketch the structure of a tree as you look up at the branches from below.

9. ☐ Look carefully at the bark of a tree and try to represent the colors that you see.

10. ☐ Sketch the same location with a high horizon line and then with a low horizon line. How does that change the scene?

11. ☐ Draw the life cycle of a flower, from bud to when the petals dry up.

12. ☐ Try a format you haven't used for a scene in nature, such as a long vertical or wide panorama.

13. ☐ Try painting just the silhouette of a plant that has an interesting shape.

14. ☐ Find a location with trees in the distance, then make simple shape studies of the different trees.

15. ☐ Choose a location with trees and other plants and try representing it with line only. Then, try it with paint only.

16. ☐ Sketch nature as the "view between," such as a garden patch between two buildings.

17. ☐ Paint clouds at the same time of day every day for a week.

18. ☐ Try using a medium you have never used before.

19. ☐ Create your entire sketch using only a wet-on-wet technique.

20. ☐ Sketch a view using simplified geometric shapes.

21. ☐ Save the white of the page to paint clouds, water, or snow.

22. ☐ Paint flowers close up using the negative painting techniques.

23. ☐ Try four different black-and-white Notan sketches to investigate your composition.

24. ☐ On a sunny day, look for trees or other foliage with strong cast shadows. Draw or paint the patterns of light and shadow.

CONTRIBUTORS

Alomar, Richard
sketchoutloud.blogspot.com
nycsketch.blogspot.com

Bajzek, Eduardo
www.ebbilustracoes.blogspot.com
@bajzek (IG)

Blaukopf, Shari
www.blaukopfwatercolours.com
@skarisketcher (IG)

Blossom, Duane
@blossomduane (IG)

Boon Sim, Tia
www.tia.mysite.com
www.facebook.com/tiastudio

Carvalheira, Genine
www.geninecarvalheira.com
@geninecarvalheira (IG)

Ching, Frank
www.frankching.com/wordpress

Ch'ng Kiah Kiean
www.kiahkiean.com

Cordero Hidalgo, William
@williamcorderoh (IG)

Darman Sketcher
www.facebook.com/darman.angir
@darman_sketcher (IG)

Dollar, Judith
@tx_sketcher (IG)

Ermilova-Terada, Mariia
@mariia_ermilova_terada (IG)

French, Kay
@kayfrench44 (IG)

Geraths, Gary
www.garygerathsart.com
@garygeraths (IG)

Godas, Maru
www.marugodas.com
@marugodas (IG)

Heaston, Paul
www.paulheaston.blogspot.com
@paulheaston (IG)

Hein, Virginia
@virginiahein (IG)

Heston, Sue
@sue.heston (IG)

Johansson, Nina
www.ninajohansson.se
@nina_sketching (IG)

Kelkar, Uma
www.umakelkar.com
@umapaints (IG)

Khashchina, Nina
@ninaapplepine (IG)

Lapin
www.lesillustrationsdelapin.com
@lapinbarcelona (IG)

Lawlor, Veronica
www.veronicalawlor.com
www.studio1482.com/veronica
@verolawlor (IG)

Linhares, Mário
hakunamatatayeto.blogspot.com
@linhares.mr (IG)

Low, Don
www.donlow-illustration.com
@donlowart (IG)

Lowther, David
www.facebook.com/ DavidLowtherArt
@DavidLowtherArtist (IG)

Luk, Ben
www.facebook.com/Sketcher Ben
@sketcher_ben (IG)

Lynch, Fred
www.FredLynch.com
@FredLynchArt (IG)

Matsukawa, Kumi
www.flickr.com/photos/macchann
@kumimatsukawaart (IG)

Murphy Frankstone, Laura
www.laurelines.com

Oliveira, Raro de
@rarodeoliveira (IG)

Portella, Grazielle B.
www.grazizarg.com

Sallés, Santi
www.santisalles.com
@santisalles (IG)

Serrano, Inma
@inmaserranito (IG)

Shirodkar, Suhita
www.SketchAway.wordpress.com
@SuhitaSketch (IG)

Tapp, Barbara
www.barbaratappartist.com

Terlinden, Don
www.donterlinden.com
donterlinden.wordpress.com
@donterlinden (IG)

Wang, Paul
paulartsg.wixsite.com/paulwang
@paulwang_sg (IG)

Wigham, Laurie
lauriewigham.com
@lauriewigham (IG)

Wiltse, Kris
www.kriswiltse.com

Wong, Gail L.
www.glwarc.com
@glwarc_seattle (IG)

Zhong, Yong Hong
www.yonghongzhong.com
@yonghong.zhong.9 (IG)

ACKNOWLEDGMENTS

Co-authoring this book was an incredible opportunity to collaborate on topics we both enjoy about Urban Sketching. With Gail in Seattle and Virginia in Los Angeles, it was a challenge to both work on this book long-distance, but in the process, we honed our online collaboration skills! Of course, we want to thank Gabi Campanario for his vision in starting this international community, Urban Sketchers (www.urbansketchers.org). Being part of this wonderful, creative community has been rewarding beyond measure.

We would like to thank all the Contributors for their generosity in sharing their work, expertise, and time. Special thanks to Ian Koppe and William Davison for their support and time in reviewing the book with fresh eyes; their feedback was invaluable. Finally, thank you to our publisher, Quarto, for giving us this opportunity to share our thoughts on urban sketching through spotlighting nature.

ABOUT THE AUTHORS

Virginia Hein is the author of *5-Minute Sketching: Landscapes*. Virginia is from Los Angeles, and the landscape of the city has always been her favorite subject. She has worked as a concept designer for toys and entertainment, art director, illustrator, and fine artist. Virginia taught drawing at Otis College of Art and Design in Los Angeles for thirteen years and currently teaches on-location sketching workshops. As a member of Urban Sketchers since 2009, she has taught workshops at four Urban Sketchers International Symposiums and has contributed her work to a number of books about on-location sketching. You can see her work on Instagram: @virginiahein.

Gail L. Wong is an architect, illustrator, educator, and urban sketcher. She has taught design drawing and architectural sketching at University of Washington in Seattle and has taught and lectured at several on-location sketching workshops through Urban Sketchers and at the Urban Sketchers International Symposiums. Gail returned to her love of sketching and painting after joining the newly formed Seattle Urban Sketchers in 2009. Her watercolor and ink sketches capture both the iconic and everyday views that are part of the urban and natural environments. Gail has also contributed to several books about on-location sketching. To see more of her work, visit her website: www.glwarc.com and Instagram: @glwarc_seattle